# PIONEERING
# *Palm Beach*

**Date: 1/28/13**

# PIONEERING

# *Palm Beach*

## ❖ THE DEWEYS AND ❖
## THE SOUTH FLORIDA FRONTIER

GINGER L. PEDERSEN & JANET M. DEVRIES

Charleston | London

THE
History
PRESS

Published by The History Press
Charleston, SC  29403
www.historypress.net

*Cover image*: Laura Woodward (1834–1926), *Workmen's Camp, Palm Beach, Florida*, circa 1893, collection of Edward and Deborah Pollack.

First published 2012

Manufactured in the United States

ISBN 978.1.60949.657.9

Library of Congress CIP data applied for.

*Notice*: The information in this book is true and complete to the best of our knowledge. It is offered without guarantee on the part of the authors or The History Press. The authors and The History Press disclaim all liability in connection with the use of this book.

*This book is dedicated to my mother, Christa E. Pedersen, whose spirit left this earth during the writing of this book. May she enjoy many lovely afternoons with the Deweys and their cats and dogs in the eternal paradise of the Blessed Isle.*

*—Ginger L. Pedersen*

# Contents

In 1895, my recently married great-grandparents, Captain Frederick and Lillie Pierce Voss, were hired by two men from Michigan, William S. Linton and Major Nathan S. Boynton, to ferry them in our family boat to the south end of Lake Worth, where the two visitors looked over some land. These men would later purchase this land, and Major Boynton would build a hotel along the beach ridge and plat a small town to the west named after himself.

So went the story that I grew up hearing and, like others, have passed along ever since. However, there was a problem with this story. It was not entirely correct. As the fine research of Ginger Pedersen and Janet DeVries uncovered, Major Boynton was not the person who platted the little town that today bears his name. In fact, it was a husband and wife named Dewey who platted the town of Boynton—today the city of Boynton Beach.

*Pioneering Palm Beach* illuminates two of the most remarkable, yet least known, personalities in Palm Beach County's pioneer history: Frederick Sidney Dewey and his wife Byrd "Birdie" Spilman Dewey. Posterity knows so little of their accomplishments and contributions because they left no children and, therefore, no one to carry on their name and story. Pedersen and DeVries, however, have uncovered their story, one that is told in rich detail in the contexts of both American history and local pioneer history.

Birdie's family history in America dates to the very origins of English colonization. Her ancestor arrived in Jamestown in 1609, was traded to Powhatan Indians for a piece of land, lived among the Powhatan, learned

their language and befriended the legendary Pocahontas. Birdie was also the grandniece of President Zachary Taylor.

Fred, a Civil War veteran from Indiana, was a cousin of Admiral George Dewey. He met and married Birdie in Illinois. Soon they moved to Florida, trying their hand at various occupations and attempting to find their Eden in different Central Florida locations before venturing deep into the vast wilderness that would later become Palm Beach County. They were true "pioneers," arriving in the years before Flagler's Florida East Coast Railway would open this vast jungle wilderness to the rest of the world.

Together, Fred and Birdie would carve out a homestead in the wilds of what would later become West Palm Beach, living in isolation deep in the pine woods with their beloved pets. They would soon acquire a beautiful waterfront parcel just south of what is today downtown and build their home, Ben Trovato, which would become an important scene of pioneer social life as Birdie ascended the ranks of the nascent Palm Beach social scene.

Along the way, Birdie wrote autobiographical accounts of their life adventures. However, she often disguised them as fictional stories, sometimes about their dog Bruno. She was an exceptional writer of national stature, with a witty and engaging style. Her articles appeared in the leading publications of her day, including *Ladies' Home Journal*, *Vogue* and *Good Housekeeping*. Her first book, *Bruno*, was a bestseller. It was published by one of America's preeminent publishers—Little, Brown and Company—alongside the works of such noted American writers as Louisa May Alcott and Emily Dickinson. *Bruno* was one of the first novels to be written in our area and marked a milestone in South Florida's important literary history. Pedersen and DeVries' expert detective work definitively ties Fred and Birdie's real-life story to the many adventures chronicled by Birdie in her popular articles and books.

Fred served as a county commissioner, county tax assessor and county tax collector at the time when this region was still part of Dade County. His responsibilities took him from the Florida Keys to the St. Lucie River. He later worked as a land agent for Henry Flagler, the father of modern South Florida, and even befriended the oil and railroad tycoon. After Fred's death, Birdie became the field secretary of the Florida Audubon Society and traveled the state lecturing on conservation. She had an uncanny ability to tame wild birds and mimic their calls.

Along the way, Fred and Birdie bought and sold landholdings from modern-day Hollywood and Fort Lauderdale to modern-day Boynton Beach, Palm Beach and West Palm Beach. They planted citrus and engaged

in all forms of agriculture. Their skills and intellectual interests were many. Their humility is evident in the fact that they owned the land and filed the plat for the town of Boynton, choosing to name the town after Major Boynton rather than themselves.

I am most grateful for the research in this book, as it has brought to light two largely unknown but certainly remarkable people in South Florida's history. Pedersen and DeVries have made an outstanding contribution to the scholarship of Palm Beach County's pioneer era.

Harvey E. Oyer III
President, Lake Worth Pioneers Association
Former Chairman, Historical Society of Palm Beach County

# *Acknowledgements*

The authors encountered so many helpful, inspiring people along the journey of researching and writing this book. Debi Murray, director of research and archives at the Historical Society of Palm Beach County, enriched the quality of the text with her limitless knowledge of resources and provided expert editing of the manuscript. Harvey Oyer III wrote the inspiring foreword from the voice and vision of his pioneer family. Professor Rodney Dillon also lent his expertise on Florida history in reviewing the manuscript.

It took many months, but locating and connecting with Byrd Spilman Dewey's great-great-grandnieces brought her present-day family into the project: Lila "Peaches" Rankin, Loretta Lydic Amerman and Janis Lydic Hebert. They shared priceless photographs and family letters.

Our editors at The History Press—Jessica Berzon, Hannah Cassilly and Ryan Finn—mentored and guided us seamlessly through the publishing process.

The following persons provided valuable resources and information:

Professor Patricia Alvarez, Palm Beach State College
Dr. Evan Bennett, Florida Atlantic University
Marlene Blye, Eustis Memorial Library
Louise Carter, Eustis Historical Society
Roger Cope, Cope Architects
Donna Corry, Flora Illinois Public Library
Beth Davis Fabiano, Greenlawn Funeral Home and Cemetery

## Acknowledgements

Jeff Geiger, Jacksonville Public Library
Thomas A. Grunwald, Sayre Institute
Richard W. Hoover, Sr., son of Judge Earl R. Hoover
Dawn Hugh, History Miami
Christine Kinlaw-Best, Sanford Historical Society
Eliot Kleinberg, *Palm Beach Post*
Teresa Martinez, Palm Beach County Clerk of Courts Office
Marjorie Watts Nelson, Genealogical Society of Palm Beach County
Dottie Patterson, Delray Beach Historical Society
Deborah Pollack, Edward and Deborah Pollack Fine Art
James Ponce, historian, West Palm Beach, Florida
Michelle Quigley, *Palm Beach Post*
Joyce Reingold, *Palm Beach Daily News*
Tim Robinson, author, Stuart, Florida
John Shipley, Miami-Dade Library
James Shires, historian, Maysville, Kentucky
Dr. Voncile Smith, Boynton Beach Historical Society
Susan Swiatosz, Flagler Museum
Jan Tuckwood, *Palm Beach Post*
N. Adam Watson, State Archives of Florida
David Willson, *Palm Beach Daily News*

Help with photograph preparation and manuscript editing came from Dr. Jennifer Campbell, Bridget DeVries, Edwin Hill, Michael Naughton, Charles Sass, Dr. Sharon Sass and Zara Siassi.

A portion of the proceeds from this book will be donated to Audubon of Florida and the Historical Society of Palm Beach County.

For more information, please see the website at www.byrdspilmandewey.com.

*Introduction*

The name "Palm Beach" brings to mind the ocean, the palms and the playground of the wealthy and famous in Florida. But few realize the humble beginnings that arose out of the sawgrass and scrub. Florida in the 1880s was a wild and scenic place, brimming with possibilities and pitfalls. It certainly attracted the wealthy, the dreamers, the builders, the farmers and the hucksters, all of whom looked in the Florida mirror and saw something very different. Among all those early Florida pioneers were two rather extraordinary individuals, both deeply rooted in American history but forgotten over time.

Florida's genesis is inherently interesting, and it begins with the land itself. Land research involves looking through massive old land tract books in the courthouse, scanning through microfilm and deciphering legal land descriptions. The authors of this book became interested in how Boynton Beach, Florida, began. The common belief was that Major Nathan Smith Boynton arrived in 1895 from Michigan, bought five hundred acres of land and built a hotel for northern guests trying to escape the cold and see the tropics. The story continued that Boynton founded the associated town to house hotel employees and farmers.

However, when the authors searched the original town site's land transaction records, it was not the name "Boynton" that was written over and over again, but someone else's name. That name was "Birdie Dewey." In page after page in the tract books, Birdie Dewey bought and sold lots and acreage. Who was this person, and why were so many land transactions under her name?

The authors searched the Internet and found that Birdie Dewey's full name was Byrd Spilman Dewey, and her husband was Frederick Sidney Dewey. The Deweys were listed on a website as being among the original pioneers on Lake Worth, the body of water that runs twenty-one miles parallel to Palm Beach County's coastal barrier island. During the Second Seminole War, soldiers named the lake for General William Jenkins Worth.

The site also revealed another fact about Birdie Dewey: she was a prominent author of her time. Now the story had its first new layer. The authors' investigations began to offer many new facts about this most interesting couple, their life in the Florida wilds and the paradise they created in West Palm Beach, Florida. It did not take long to locate Birdie's first book, *Bruno*. The book was found in a 1906 Christmas catalogue selection publication. Further research revealed that the Google Books project had scanned *Bruno* as part of the initiative to preserve out-of-print books.

Published in 1899, *Bruno* is the story of a beloved dog the Deweys once owned. Labeled as a children's book, it is one of those books that can be read by someone of any age and have a different meaning and significance. But the book's setting was even more intriguing—the story was told against of the backdrop of their early pioneer days in Florida. The book's characters are named Judith and Julius, but research will show that they are stand-ins for Fred and Birdie.

After the authors read *Bruno*, it was clearly evident that these were not ordinary people, nor was this an ordinary story. Her writing showed great literary ability and a hypnotic and lyrical writing style that enchants the reader. Excerpts from *Bruno* will guide the reader through this book's early chapters, as it chronicles the Deweys' difficult beginnings in Florida. Many passages from her other writings will also provide clues and insights into the Deweys' life in Florida. These first clues started an intense research effort to uncover the Dewey story through modern methods on the Internet and old-fashioned detective work through telephone calls, letters and road trips to the various locations where the Deweys had lived around Florida.

Although the following chapters are chronologically organized, the story unfolded in a nonlinear fashion. After finding *Bruno*, the authors found references to an additional book entitled *The Blessed Isle and Its Happy Families*, held in a few libraries. What was *The Blessed Isle*? Did Birdie write other books? The authors phoned the Historical Society of Palm Beach County to see if there was additional information on the Deweys; in fact, the society's archives contained a Dewey folder. The authors went to the archive in the old courthouse in downtown West Palm Beach, Florida, the

county seat. The society's archive file provided the first in-depth information on the Deweys.

A Cleveland, Ohio judge found the crucial clues to tell the Dewey story. Judge Earl R. Hoover was a historian who had done much to chronicle Cleveland's history, and he had become particularly interested in Jonathan Edwards Spilman, a Kentucky reverend who had written one of the most beloved melodies in America, namely "Flow Gently, Sweet Afton." In his research on Reverend Spilman, Judge Hoover had also uncovered Reverend Spilman's daughter, Byrd Spilman Dewey. He became so fascinated with her and the mystery of why she was so unknown that he conducted his own investigation when he visited the West Palm Beach area in 1966. His detailed, twelve-page chronology of Birdie's life laid a foundation on which the Deweys' time and life in Florida could be chronicled, particularly their time in South Florida. The authors used his meticulous research as a reference throughout the writing of this book.

The most significant find was yet to come. An article from a 1909 Maysville, Kentucky newspaper mentioned that the Deweys were visiting Maysville, Birdie's childhood home, and that she had published an article series entitled *From Pine Woods to Palm Groves* for the *Florida Review*, a literary journal. After much searching, the authors found the 1909 journal in the Jacksonville City Library. It proved to be a well-written and detailed account of Palm Beach County pioneer life and was a significant historical discovery that sat unnoticed in an obscure journal for more than one hundred years.

With these introductory words, the story to be told will ensure the Deweys' place in Florida's history, as well as share Birdie's writings and philosophy with a new audience. Much of the evidence found will also rewrite history books as to the beginnings of one of Palm Beach County's major cities. The Deweys' journey through Florida spans more than sixty years through the incredible growth of the period from 1881 through 1942. They were alongside the greats of the era, including Henry M. Flagler, oil and development tycoon, and the world resort he created in Palm Beach. The Deweys saw it all, and Birdie's pen captured it for future historians and readers to rediscover their amazing story.

# The Spilmans and the Taylors

The Spilman family's start in the mysterious and foreign place called America is an interesting tale. The year is 1609. A boy of thirteen has boarded a ship in England named the *Unity*, and it is headed to resupply a fledging town in the New World called Jamestown. That boy, Henry Spelman, arrived in Jamestown in October 1609. Henry paid for his passage by being an indentured servant. After less than two weeks in Jamestown, Henry met Captain John Smith. Young Henry was essentially "traded" to the Powhatan Indians for a piece of land and was to live among the Powhatan Indians and learn their language and culture so that the colonists could befriend and trade with the Indians. With the coming winter, the fledging colony could not support itself with the meager supplies and crops they had. Upon the supply ship's arrival from England, the *Unity*'s crew and passengers found the surviving colonists in very poor condition, with only one-third of the original colonists still alive.

Henry learned the Powhatan language and lived among the Indians, and he helped the colonists barter with the Indians, often trading copper for food. At one point, hostilities between the colonists and the Indians reached a critical point, and Henry fled the Powhatan village with a friend, seeking refuge with the neighboring Patawomeck Indian tribe. The Patawomeck Indians captured the boys, and the tribesmen killed Henry's friend. John Smith wrote the following on Henry's fate in his work *Generall Historie*: "Pokahontas the King's daughter saved a boy called Henry Spelman that lived many yeeres after, be her meanes, amongst the Patawomecks." Henry

did live with the tribe and married a Patawomeck woman, who took the English name Martha Fox; Spilman family lore has noted that Fox was one of Pocahontas's many sisters.

Henry continued to travel between Jamestown and England and wrote of his adventures among the Indians in his manuscript *A Relation of Virginia*, one of the earliest accounts of Indian culture and lifestyle written at the time of the events, published in 1872. He provided his own motivation for seeking a new life in the New World in that manuscript: "Being in displeasure of my friends, and desirous to see other countries." With time, relations with the Indians soured further, and they wanted the English to leave their lands; the Jamestown massacre ensued in 1622. Henry survived the massacre, but on March 23, 1623, he met his fate when Anacostan Indians attacked his expedition party on the Potomac River. Henry was only twenty-seven when killed, and he left behind his wife, two brothers and one son, Clement. Soon the spelling of the family name changed, becoming Spilman.

And so came Byrd ("Birdie") Spilman Dewey's first ancestor to America. Birdie's deep ties to America's founding are ones that very few Americans can claim. In addition to the connections to Pocahontas and John Smith, she was William Brewster's descendant, a signer of the Mayflower Compact and a passenger aboard that ship; she was also related to William Penn, Pennsylvania pioneer, and John Edmund Pendleton, who authored the Continental Congress resolution that allowed Thomas Jefferson to draft the Declaration of Independence. But her closest famous family line came through her mother's family, the Taylors of Virginia and Kentucky.

Kentucky's green hills drew many settlers to the new frontier; among them were two Virginia brothers, Richard and Hancock Taylor. The Taylor brothers spent years surveying the area and found the new lands very inviting. During the 1774 expedition, local Indians killed Hancock Taylor, thus becoming the first European American to die in Kentucky. His brother, Richard, acquired eight thousand acres of land in the Kentucky territory, and he built his home, Springfield, on a four-hundred-acre estate in what became Louisville, Kentucky. The home is known today as the Zachary Taylor House.

Richard Taylor became a Revolutionary War colonel and had many sons. Among them was another Hancock Taylor, named for his lost brother, and another son whose name is quite familiar to American history students: Zachary Taylor. Born in 1784, Zachary grew up on the Springfield estate in Louisville. Zachary had a long and distinguished military career, including campaigns in the War of 1812, the Mexican-American War, the Black Hawk

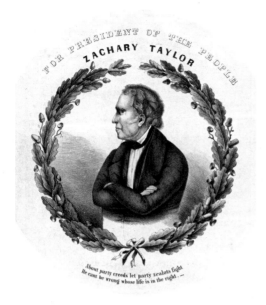

ZACHARY TAYLOR FOR PRESIDENT.
Julia Byrd Spilman Dewey's maternal
great-uncle, Zachary Taylor, known as
"Old Rough and Ready" during his
campaign for president. Taylor served
as the twelfth president of the United
States. *Courtesy Library of Congress.*

War and the Second Seminole War in Florida. In 1848, Zachary Taylor
became the twelfth president of the United States, with Millard Fillmore
as his vice president. Hancock Taylor, Zachary's brother, married Annah
Hornsby Lewis in Kentucky, and together they had ten children, including
Eliza Sarah Taylor, Birdie's mother. Thus, Birdie was President Zachary
Taylor's grandniece. Birdie knew this fact, and it always appeared in her *Who's
Who* biography.

As the successive Spilman generations spread across America, Jonathan
Edwards Spilman, Birdie's father, was born on April 15, 1812, in Muhlenberg
County, Kentucky. His parents were Benjamin Franklin Spilman and
Nancy Jane Rice, and together they had thirteen children—five sons and
eight daughters. Nancy served as tutor for Jonathan, according to Spilman
biographer Malcolm Melville: "She was a woman of exceptionally strong
character and was descended from an ardent Presbyterian family prolific in
ministers." The Spilman family moved to Carmi, Illinois, when Jonathan
was a child.

Much is known about the Spilman family during this era because of Judge
Earl R. Hoover's 1968 article, published in *The Register of the Kentucky Historical
Society*. Hoover, a Cleveland, Ohio historian, discovered the Spilman family
story during his research on Jonathan's life and career. Hoover noted that
as a youth, Jonathan struggled with his choice of vocation, as his brothers

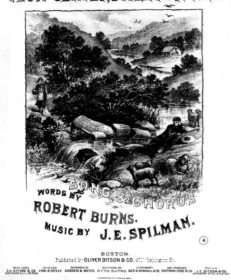

"FLOW GENTLY, SWEET AFTON" SHEET
MUSIC. Jonathan Edwards Spilman
composed the music to "Flow Gently,
Sweet Afton" while a student at
Transylvania College in Kentucky.
In 1838, the tune, set to the famous
Robert Burns poem, was published in
Pennsylvania. The popular melody is
often sung to the lyrics for "Away in the
Manger." *Courtesy Library of Congress.*

were either ministers or physicians. Jonathan studied with his mother until
he was seventeen and continued his schooling with his brother, Reverend
Thomas A. Spilman, at Illinois College, intending to enter the ministry.
Edward Beecher, brother of famed author Harriet Beecher Stowe, served as
the fledging college's first president. In 1835, Jonathan was one of the first
two Illinois College graduates, a fact that is still acknowledged on the Illinois
College website. The other graduate, Richard Yates, became the Illinois
Civil War governor and a United States senator.

Instead of entering divinity school, Richard and Jonathan continued their
studies at Transylvania College in Lexington, Kentucky, to read law and become
attorneys. Here Jonathan found his way to immortality and composed one of
the most beloved melodies in American music, namely "Flow Gently, Sweet
Afton," a tune set to the famous Robert Burns poem. Judge Hoover puts it this
way: "Under the spell of immortal poetry, from some unknown somewhere,
there came to Jonathan Spilman the strains of an immortal melody—strains
that neither he nor anyone had ever heard—strains that fit into the company
and do honor to the lines of a Robert Burns poem. And Jonathan Spilman,
student of law who had tabled a call to the ministry, jotted them down there
that day under a black locust, Transylvania campus tree."

Jonathan played the tune for friends, who suggested publication. In
1838, "Flow Gently, Sweet Afton" was published in Philadelphia, and the

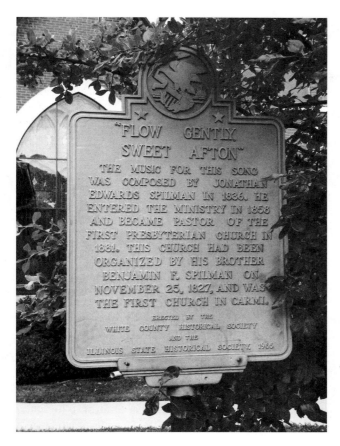

"FLOW GENTLY, SWEET AFTON" HISTORICAL MARKER. A historic state marker in Illinois pays homage to Jonathan Edwards Spilman. Another historic marker in Greenville, Kentucky, also immortalizes him. *Courtesy J. Stephen Conn.*

song became a standard in nineteenth-century American songbooks. The tune is often sung to the lyrics for "Away in a Manger." The beloved song was immortalized in not one but two historical markers for Jonathan, in Kentucky and Illinois.

Jonathan ran a successful law practice in Nicholasville, Kentucky, from 1838 to 1849 and married Mary Menefree in 1840. This union brought Jonathan the first of many heartbreaking events. Mary died after giving birth to an infant daughter, just three years after their marriage. The infant died nine months later.

In 1845, Jonathan's heart once again found its love, this time with Eliza Sarah Taylor, Hancock Taylor's daughter. Jonathan was thirty-three at the time, and Eliza was twenty-three. They lived in Nicholasville, Kentucky, and ten children blessed the marriage. But this happiness was short-lived, as tragedy awaited the family.

# "One Awful Night in My Tenth Year"

It seemed that everything in Jonathan's life was coming together—a successful law career; a new marriage into one of America's premier families, the Taylors; and the blessings of many children. How exciting it must have been for the Spilman family as Zachary Taylor was elected president in 1848. Taylor's tenure as president was short-lived, though, as he succumbed to illness on July 9, 1850, a few days after watching the Washington Monument groundbreaking on the Fourth of July. He served less than two years as president.

Six of the ten children born to Jonathan and Eliza survived to adulthood. Their first child, Charles Edwards, was born in 1847 at Nicholasville, followed by Anna Louise, Mildred Wilson, Richard Henry, Eliza Allen, William Magill, Julia Bird (Birdie), Clara Lee, Frances Rice and Lewis Hopkins. Birdie was called "Snow-Bird" by her brothers and sisters. Birdie wrote in a 1930 letter to Rosamond Gilder, daughter of poet Richard Watson Gilder: "I was 'Snow-bird' till my fifteenth year, when my elder brothers and cousins changed it to 'Lady-Bird,' and I never felt really 'grown-up' till I married." She was in the middle of these many children and wrote to Gilder: "You were very young, and very much younger than your years, because of being 'the baby.' I know how that is, for I was 'one of the children' in our family, being the seventh child in a family of ten children."

CHILDREN OF JONATHAN EDWARDS SPILMAN AND ELIZA TAYLOR SPILMAN

| Name | Born–Died | Spouse | Profession |
| --- | --- | --- | --- |
| Charles Edward Spilman | 1847–1921 | Elizabeth Spilman | bookkeeper |
| Anna Louise Spilman | 1848–1945 | never married | keeping house |
| Mildred Wilson Spilman | 1849–? | died in childhood | |
| Richard Henry Spilman | unknown | died in childhood | |
| Eliza Allen Spilman | unknown | died in childhood | |
| William Magill Spilman | 1854–1926 | unknown | unknown |
| Julia Bird Spilman | 1856–1942 | Fred S. Dewey | author |
| Clara Lee Spilman | 1857–1930 | George W. Andrews | keeping house |
| Francis Rice Spilman | 1859–? | died in childhood | |
| Lewis Hopkins Spilman | 1860–1939 | Lillian Spilman | attorney and author |

The Spilman family remained in Nicholasville, Kentucky, until 1849 and then moved on to Covington, Kentucky, where they lived until 1856. Jonathan's law firm had three attorneys: Jonathan; Samuel M. Moore, who went on to become a judge in Chicago; and John W. Menzies, who went on to a career in politics in the United States House of Representatives, representing Kentucky in 1860. His law partner's political aspirations meant that the bulk of the work fell on Jonathan. It became too much for him, and he gave up his law practice in 1856, nearing a mental breakdown.

At the age of forty-six, Jonathan did something rare for the time. He changed careers and followed his original calling, namely to be a Presbyterian

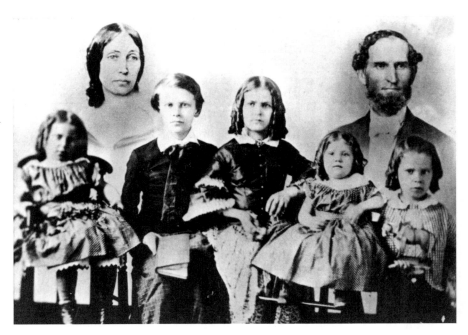

SPILMAN FAMILY. Jonathan E. Spilman and Eliza S. Taylor had ten children, six of whom survived to adulthood. Birdie is pictured on the left side of the image below her mother. The other children in this undated image are (left to right) Charles Edwards, Anna Louise, Clara Lee and William Magill. *Courtesy Janis Lydic Hebert.*

minister., He began a home study program with the West Lexington Presbytery and received his license to preach in April 1858, along with his doctorate in divinity from Central University. The Presbytery of Ebenezer ordained Jonathan in June 1859, and his first pastorate was in the Second Presbyterian Church in Covington, Kentucky. His second pastorate took the family to Nicholasville, Kentucky, where he was instrumental in founding the Presbyterian church in that city.

The Civil War years were difficult, especially living in Kentucky, which drifted between Union and Confederate forces. From *Harper's Weekly*, September 27, 1862: "Covington today presented an almost dilapidated appearance; but few of the inhabitants were visible, stores all closed, and the streets were occupied entirely by troops moving or vehicles attached to the army. The buildings looked as if erected in year One, and in my judgment, the country would suffer but little loss were Covington wiped out."

In 1864, the family moved to Maysville, Kentucky, where Jonathan became pastor at the First Presbyterian Church, founded in 1817. Maysville is a picturesque town perched above the Ohio River and was an important

river port for many years, with tobacco and hemp exports. A tragedy played out here that forever changed the Spilman family.

On a warm summer evening in August 1866, the Spilman family was busy preparing a special party for mother Eliza, who was leaving at dusk to visit son Charles, nineteen, downriver in Cincinnati, Ohio. The brand-new, beautiful modern steamer *Bostona No. 3* awaited its passengers at the wharf. The *Bostona No. 3* mail packet plied the Ohio River between Maysville and Cincinnati, some sixty-three miles downstream. Eliza's party was held at the manse, and the family accompanied her down to the wharf, rushing home so they could stand outside the home and wave their handkerchiefs as the steamer passed directly by the manse perched above the river. Judge Hoover wrote, "As the majestic *Bostona No. 3* approached the Spilman home, the family saw Eliza at the ship's rail and she saw them. From ship to shore and from shore to ship, happy handkerchiefs shouted 'goodbye,' but now something injected itself that wasn't planned. As they waved, suddenly the family became aware of a danger of which Eliza was not aware."

As darkness descended, the steamer left its moorings at about half past eight o'clock in the evening. A passenger on board the *Bostona No. 3*, L.D. Carter, wrote his chilling account about what happened that night for the *Gallipolis Journal*:

> *In two minutes after the alarm was given, the fire was sweeping through the cabin. It caught fire from the lamp of the watchman, who had gone back to secure the tying of some cattle that had been taken aboard at Maysville, broke the bottom out of the lamp, causing the oil to spill on some dry lumber, which caught on fire in an instant. The fire appeared to rage most terrific in the stern of the boat, the wind being in our favor while the boat was under headway; but so soon as the boat struck the sand bar, the fire came like a torrent up the bow, cutting everything before it. The whole affair was a horrible scene, unparalleled by anything I ever saw, the dying groans of the soldier on the battle ground not excepted.*

In her attempt to escape, Eliza ran down the ship's deck. Just then, a steam pipe burst, spraying her with scalding water. She fell there, severely burned. Passengers placed Eliza in a rowboat, and they took her home across the river. She somehow managed to climb up the hill to the manse. The *New York Times* reported on August 12, 1866, "Among those who were scalded and otherwise injured was Mrs. Spilman, the estimable wife of Reverend J.E. Spilman, of Maysville. Her injuries are serious, she being scalded in the face and hands."

Among the many passengers and crew aboard the *Bostona No. 3* that fateful night, there was but one fatality: Eliza. She died at home on August 10, 1866, leaving behind her husband and six children. Such a horrific event must have left the children and Jonathan permanently changed; Jonathan was left with his five young children. Birdie mentions the incident one time in her writings, in her book *Bruno*, when describing her feelings on seeing a neighbor's house on fire: "A fire fills me with horror, especially if it breaks out in the night: it always reminds me of the burning of a big steamer that happened one awful night in my tenth year."

The 1870 census still had the family living in Maysville, with twenty-two-year-old Mary McCue living in the household, no doubt helping with the children and keeping house for the reverend. Jonathan never remarried. Birdie wrote of her father's preaching in Maysville, in the 1909 *Maysville Public Ledger*: "The old Church opposite the January home is so little changed that it is difficult to realize the thirty-three years of absence; and one sees, with the spiritual eyes, that silver-haired Clergyman who stood up in its pulpit that many years ago, to preach the farewell sermon to the beloved flock he had so faithfully led for thirteen changeful years." Jonathan was much loved by his congregations, and his sermons were memorable. He delivered a eulogy for a prominent Maysville resident, Mrs. Sarah Huston January, and it was reprinted by popular demand.

As the children were growing up without their mother, Jonathan knew that his daughters needed guidance and attention that he perhaps could not provide. He certainly knew the value of a good education, not only for his sons, but for his daughters as well. In the 1870 census, his son Charles, the oldest, was listed as "bookkeeper" and living at home. The rest of the children were in school at various points in their education. Kentucky's excellent schools allowed Jonathan to choose good educational institutions for his children. Birdie described her schooling in a 1909 essay that appeared in the *Maysville Public Ledger*: "The little old schoolhouse in the back room of the Third Street Methodist Church, where Mrs. Pears used to hold restless little girls and boys at their books for five mornings and afternoons a week, from September to June of every year, is still here." Birdie attended Maysville Academy, Maysville College, the Maysville Institute and the Sayre Institute in Lexington, Kentucky.

David Sayre, a wealthy silversmith from New Jersey, founded the Sayre Institute in 1854. At that time in Kentucky, colleges did not accept women, but Sayre felt that women needed access to higher education. The Sayre Institute was a boarding and day school that offered young women a complete

curriculum. From the *Kentucky Statesmen*: "The object of the institution is to afford to young ladies a liberal and finished education in all those branches of useful and elegant learning which contribute to the accomplishment of the female sex." Major Henry B. McClellan served as headmaster, cousin to Civil War general George B. McClellan.

The charge for twenty weeks of instruction, including room and board, was $100, a considerable sum at the time. From *A Centennial History of Sayre School* by J. Winston Coleman: "Board, with room furnished in a superior manner for four occupants, fuel, gas-light, washing, pens, pencils, copy-books or exercise books, and tuition in the regular higher course, including Ancient Languages and Sacred Music." The curriculum included courses in algebra, astronomy, chemistry, mental and moral philosophy, history, geometry, rhetoric, trigonometry, moral science, English literature, Latin, geology and the study of a classic religious text, *Butler's Analogy*, and Kame's *Elements of Criticism*, a two-volume classical work on the "science of criticism." Extra studies were offered in instrumental and vocal studies, drawing, painting, French and experimental chemistry. Based on newspaper accounts and letters, Birdie was quite proficient at the piano, having one in almost every residence in which the Deweys lived, and her French was advanced enough that she could translate for other writers. She also was a talented painter, a skill that served her later in Florida. As far as mathematical ability, she stated, "I have ever belonged to that grand army of women who have to count on their fingers to make change."

From this educational background, Birdie discovered literature and music, the two greatest loves of her scholarly life. In her writings and letters, she draws quotes and analogies from all the great writers. According to Thomas A. Grunwald, Sayre's director of alumni affairs, school records do not show that Birdie graduated from the Sayre Institute. It could be that a family move did not allow her to graduate. Nonetheless, this rigorous education blessed her with the love of literature and writing that was to guide her all her life. The family move to Illinois would bring her a man and a dog that proved to be very special, as well as act as the springboard toward the beginning of the Florida adventure.

# *Westward to the Land of Lincoln*

In 1876, the Spilman family left Kentucky and headed west to Jonathan's next pastorate in Salem, Illinois, a small town in Marion County. William Jennings Bryan, the famous orator who was the Democratic nominee for president on three occasions, was born in Salem in 1860. A devout Presbyterian, he no doubt attended many services preached by Reverend Spilman. Birdie was now twenty years old and had moved with the family to Salem, although no information was found as to what the type of work she may have done. She probably cared for younger siblings, did household chores and attended services in her father's church. In all likelihood, it is where she met a man who was her life's love, Fred S. Dewey.

Frederick Sidney Dewey was born on October 10, 1837, in Bloomfield, Indiana, the son of Lonson Dewey (from Massachusetts) and Nancy Jones (from Connecticut). It was always noted in Birdie's biography that Fred was a "cousin" of Admiral George Dewey, who won fame for his victory in the Battle of Manila Bay on May 1, 1898. Thomas Dewey was the original Dewey in America, often called "Thomas the Settler." Thomas had come to New England in 1633 from Sandwich in Kent, England, and had settled in Windsor, Connecticut. He was granted the status of "freeman" in 1634, which gave him rights to receive land grants and to vote.

Fred and Admiral Dewey were distant cousins, descended from different sons of Thomas Dewey—Admiral Dewey was descended from Josiah, while Fred was descended from Jedediah. Fred's connection to Thomas the Settler goes back seven generations, where each man was a farmer, primarily in

Westfield and Great Barrington, Massachusetts. So much is known about the Dewey line because of the 1898 book *Life of George Dewey*, written by Adelbert M. Dewey, which recorded the ancestry of more than fifteen thousand Deweys in the United States, all descended from Thomas the Settler.

Over time, the Deweys had spread out across America from the many sons of Thomas, into learned and common professions. Among those most well known are Melvil Dewey, who developed the Dewey Decimal System of library classification; John Dewey, philosopher and educator; and Thomas Dewey, politician. Fred had one sister, Hattie, and three brothers, Galusha, Berny and Frank. The family appeared in the 1860 census living in Scott, Illinois.

Fred next emerges in the historical record for his Civil War service. He enlisted in the Union army on August 15, 1862, at Carondelet, Missouri, near St. Louis, serving in the Thirty-first Missouri Infantry. It is not known if Fred moved to Missouri from Indiana or if other family had relocated to the town. He was assigned as company clerk and by September had been promoted to sergeant major.

Illness soon found Fred as the result of the deplorable conditions under which most soldiers served in the Civil War. Poor food, little or no sanitation and exposure to the elements left many soldiers open to illnesses prevalent at that time. After only two months of active duty, Fred fell ill with a respiratory disease, or what was called "phthisis," the Greek name for the disease commonly known today as tuberculosis. He was reduced in rank to private, by his wish, in November 1862. He was first in the military hospital at Jefferson Barracks in St. Louis, where he remained until July 1863. Fred was then transferred to Camp Sherman in Bovina, Mississippi, near Vicksburg and discharged due to his disability on September 6, 1863, by General Ulysses S. Grant. As his discharge papers noted, "He acted as clerk for the Outfit for the first two months since which time he has done no duty of any consequence in the last twelve months he has done hard to exceed two months duty and certainly has consumption or other pulmonary disease as to unfit him for service, signed Captain John Reed."

Adjutant Surgeon Horace Nunell also wrote on Fred's discharge papers, "I certify that I have carefully examined the said Fred S. Dewey of Captain John Reed's Company, and find him incapable of performing the duties of a soldier because of Phthisis. I declare my belief that he will never be able to resume the duties of a soldier. I further declare my opinion that if he remains in the service it will result in his death. He is unfit for the Invalid Corps." The Invalid Corps was composed of two battalions of disabled or invalided men who could do light duty as sentinels, complete paperwork or

perform hospital duty. Fred was deemed in too dire a shape for even those duties. The discharge papers indicated that Fred was returning to Pevely, Missouri, southwest of St. Louis.

The years between 1863 and 1874 did not provide any documentation on Fred's activities or whereabouts. Given his tuberculosis, which proved fatal for many, it is not known if he recuperated with family or somewhere else. In an 1874 Illinois Senate record, Fred was appointed as a notary public for the town of Salem, Illinois. In 1876 or 1877, Birdie Spilman met Fred Dewey, and they were married on September 25, 1877. "Birdie" was the name that appeared in the Salem marriage registry book. The matrimonial ceremony was, of course, performed by Reverend Jonathan E. Spilman, one of two ceremonies he conducted that day.

And so began the wedded life of Fred S. Dewey and Birdie Spilman. Fred was eighteen years older than Birdie and thirty-nine years old when they married. It was unusual at that time for a man to remain unmarried for so long; record searches in several states, however, failed to find any previous marriages.

It is at this point that much of the Dewey story can be based on what appears in the book *Bruno*, the story of their beloved dog. Birdie's writings at first glance appear to be fictional stories based mostly on human-pet interactions. In these stories, Birdie becomes the character of Judith and Fred the character of Julius. Why she picked these particular names is unknown. Speculation could be as simple as the fact that she liked the way the names sounded together or that they were perhaps favorite characters from books she read. For clarity's sake, when quoting from *Bruno*, their actual names will be used instead of Judith and Julius.

A first reading of *Bruno* did not reveal many details or clues, as it occurred at the beginning of the research for this book. However, as more facts about the Deweys emerged, a sort of "Bruno code" came to light, where documents such as land transactions, newspaper articles and historical accounts from reference books perfectly matched the story being told in *Bruno*. The object then became to crack the Bruno code to reveal the actual names of the persons and places about which she wrote. That effort was largely successful, and it added additional depth to the story of *Bruno*, especially in relation to the move to Florida and their first stint at pioneering. Part of the reason she may have changed the names of places and people was to not offend actual persons or to disparage the places in which they lived. As the story will tell, their initial experiences in Florida were challenging.

*Bruno* opens with the Deweys living in Salem. Birdie wrote: "We do not count the first half-year of our married life, because, during that time we did

not live, we boarded. Then we found we had developed a strong appetite for housekeeping, so we began to look about for a house." In *Bruno*, she said that Fred "does office work" but did not reveal where he worked. He listed "Clerk in Bank" as his occupation on the 1880 census, and he appeared in an advertisement for *The Book-Keeper*, a nineteenth-century journal, on September 28, 1880: "From Fred S. Dewey, Book-keeper, Salem National Bank, Salem, Ill: You have succeeded far beyond my expectations in making your paper interesting and valuable." Birdie listed her profession on the 1880 census as "keeping house." Their life in Salem was undoubtedly a time of wedded bliss: "While we were furnishing and embellishing this our first home was, I think, the most entirely happy times of our lives." She quoted Fred: "I know why the birds always sing so joyously when they are building their nests."

One of the first issues to be settled in the Dewey household was that of pets. Birdie quoted Fred: "Well, I'll tell you one thing, Birdie: We never want to own any cats." Growing up, Birdie had always had cats at home, so the thought of having a "cat-less hearth," as she puts it, did not please her. After several months, Fred wondered if Birdie was lonely during his long workdays at the bank. He asked her about it, and yes, she was lonely. A cat offered company, but she knew that he hated cats. He wanted to please her and said that as long as the cat kept out of his way while home, it was all right.

The following day, a bank customer mentioned to Fred that his Blue Maltese cat had kittens, and Fred asked if he could have one. Fred was excited to come home early and tell Birdie that a kitten was headed her way. The kitten was christened "Rebecca," named for Tom Sawyer's girlfriend, as the neighbor's Maltese cat was named "Tom"; he paraded in front of Birdie's cat as she sat in the window, reminiscent of a scene from the book *Tom Sawyer*. This pet was the first of many that the Deweys had over their marriage, and their pets were the subjects of Birdie's most remembered and popular writings.

The next pet in the Dewey household was one that stole not only Birdie's heart but the nation's as well. Fred's sister, Hattie Elder, was living in an apartment in Chicago. They had been given a puppy that soon outgrew their small living quarters with two sons and husband. She wrote to Fred, "Would you like a nice dog? The children have a valuable puppy, seven months old, given to them, and we cannot keep him here, in a flat. He is half setter and half water-spaniel; pure on both sides. We call him 'Bruno.'" And so started a relationship with a dog that was to so inspire Birdie that the dog became the subject of her bestselling 1899 book, which remained in print for more than twenty years. She wrote of Bruno, "There was something

about the sympathy of that dumb creature which touched a chord not to be reached by anything human. It was so unlooked for and so sincere."

As Bruno grew, it was time for him and Rebecca the cat to meet. At that time, Rebecca had kittens in the stable, and Birdie carefully brought Bruno in to meet the kittens when Rebecca returned from a hunt: "Rebecca received him with a flash of her paw which left a long deep scratch on his nose. He retreated whining and growling. Fred comforted him, while I took Rebecca in hand. For some time we reasoned and experimented with them, until finally we had the satisfaction of seeing Rebecca let down her bristles and begin to purr while Fred smoothed her head and back with Bruno's paw."

With kittens, Rebecca and Bruno in the household, the Deweys had their first family of sorts. Birdie often referred to the pets as "the livestock": "For greater convenience we always spoke collectively of Bruno, Rebecca and her kits, as 'the cattle.'" Keeping a big dog did prove difficult, and he ran several miles from home to chase sheep. At one point, the Deweys had given Bruno away to a local hunter, but Bruno refused to eat for him and the dog ran home each chance he saw: "We were just starting for home, when on the sidewalk there was a sudden flurry and dash, I fell on my knees to hug him; and Bruno, stomach to earth, was crawling about us, uttering yelps and whines that voiced a joy so great it could not be told from mortal agony. We had given him away without his consent, and he refused to be given; so the trade was off. He stayed closely at home now, seeming to think we might disappear again if he did not watch us."

Things were clicking along in the Dewey household. No doubt it was about this time that Birdie had started sending in literary pieces such as short stories to the popular periodicals of the time. Fred was still at the bank, but his health was suffering from the long-term effects of tuberculosis: "Fred had always dreaded the bleak northern winters, having some chronic troubles, a legacy of the Civil War. It is only in literature that a delicate man is interesting; practically, it subjects him to endless trials and humiliations, so we never gave his state of health as a reason for the proposed change. Instead, we flourished my tender throat. A woman may be an invalid without loss of prestige, so not one of our friends suspected that our proposed change of climate was not solely on my account."

It was at this point that the word "Florida" entered the Dewey lexicon. A neighbor had visited Florida with a glowing report: "We were greatly interested, and at once sent off for various Florida papers, pamphlets, and books." So the house in Salem was put up for sale, and the Deweys would soon be off to start their sixty-year adventure in the faraway land of Florida.

# "Begin to Talk Florida"

Today's Florida is seen by the average visitor or resident as a series of broad urban metropolises with only occasional patches of green space and forest. The state has been drained of much of its waters and swamps, and the drainage and reclamation efforts have made Florida livable, arable and prosperous. The 1881 version of Florida that the Deweys encountered would have been quite unrecognizable in comparison to today's modern urban communities. Florida's northern part, bordering Georgia, had vast pine woodlands, dotted with cabbage palms. Small rolling hills and dark red clay soils abounded in the inland areas. The coastal areas had palmetto and oak scrub lands along the uninhabited oceanfront. This land above Orlando was where Florida's first population boom occurred after the Civil War. Reconstruction had left the state of Florida broke and desperate for new settlers to tame the land as farmers and storekeepers and to serve as the hosts of northern visitors seeking a warm winter in a mysterious and new frontier land. Key West was an entirely different place than the rest of Florida, being more akin to the Caribbean and having little in common with the peninsula's topography, lifestyle and climate.

The early Northern Florida settlers tried to make the area a much more tropical place than it actually is. Visitors in the 1870s and 1880s saw numerous orange groves and other semitropical vegetation as far north as Jacksonville, something unheard of today even in current times of rising temperatures. Even then, the oppressive summer heat was recognized; from Daniel G. Brinton's 1869 book *A Guide-book of Florida and the South: For Tourists, Invalids and*

*Emigrants*: "The season for Southern travel commences in October and ends in May. After the latter month the periodical rains commence in Florida, and the mid-day heat is relaxing and oppressive. About mid-summer the swamp miasma begins to pervade the low grounds, and spreads around them an invisible poisonous exhalation, into which the traveler ventures at his peril."

Growing cities were found on the west coast as well, such as Pensacola, where timber, cotton and brickmaking prevailed. Many businesses supported by the land along the Pensacola, Tallahassee and Jacksonville line were involved with lumber mills, both for longleaf and slash pine, and for felling the ancient massive oak and cypress trees found in the area. These businesses were involved with what was called "naval stores," or the production of masts, planking, turpentine, rosin and other supplies to support shipbuilding and maintenance.

Much of the rest of Florida, south of Lake Okeechobee, was the great unknown area of the Everglades, the wilderness and swamp region that could only be tolerated by a few hunters, squatters and others who truly wanted to live in an uninhabited land. In all of Dade County, which at that time spanned from the Middle Keys all the way to the St. Lucie River, lived only 257 people, not counting the Seminole Indians tucked away in the vast Everglades hinterlands.

Then there was Key West, that rowdy town at the United State's southernmost point that had flourished in the Civil War because of its strategic location. The town's main industries were wrecking, sponge diving and salt production for food preservation. Any mail destined for Dade County far to the north was always taken first to Key West. It was not until 1900 that Jacksonville surpassed Key West as the most populated city in the state.

In 1880, about 270,000 people called Florida home. Although the population was small in comparison to the 2010 population of 19 million, it had grown by 43 percent from just ten years earlier. Key West was the largest city in the state, with about 10,000 residents, and Jacksonville was growing rapidly and was an important industrial city, with train connections, lumber mills, shipping interests and water access to the middle of the state via the St. Johns River. Other cities prospered as well, including Tallahassee, St. Augustine and Pensacola. Orlando had also started to emerge as the center of what was then called "South Florida." The Orlando area, located in Orange County, had high rolling hills, was dotted with many large lakes and was readily accessible by steamer from Jacksonville by going up the St. Johns River through the chain of lakes to various settlements along the way.

The information that Fred and Birdie might have used to make that brave decision to move to Florida was firsthand travel accounts by friends and relatives and the books and promotional materials that were widely

distributed at the time. As Birdie alluded to, health was a major reason why they were considering relocating to a warmer environment, as many people sought warmth to alleviate the common respiratory ailments of the time, asthma and tuberculosis. Many northern cities were choked with poor air, especially during the winter months, when hundreds of chimneys and smokestacks billowed with wood and coal fires to keep residents warm.

Some of the publications the Deweys might have read at the time spoke of Florida in glowing terms, providing a utopian picture of a land filled with flowers and sunshine. In *Bruno*, Birdie does not list any specific books or materials they read, but a search through several archives provided a good representation of what those publications would have been. Other publications provided a more accurate picture of what would be encountered in Florida, including exposure to some diseases that were not present or common in northern climates, such as yellow fever and malaria. No one understood at that time how such diseases were spread, namely through infected mosquitoes. Mosquitoes were thought of as merely a nuisance, not as harbingers of disease. As Daniel Brinton recommended, "A strong, silk mosquito net, with fine meshes, will be highly prized in the autumn nights. A teaspoonful of carbolic acid or camphor, sprinkled in the room, or an ointment of cold cream scented with turpentine, will be found very disagreeable to these insects, and often equally so to the traveler."

Sidney Lanier's 1876 book *Florida: Its Scenery, Climate and History* no doubt served as a primer for the Deweys on their soon-to-be adopted home. Lanier stated, "Florida is the name as well of a climate as of a country… the gayest blossoms of metropolitan midwinter life, at the same time spreads immediately around these a vast green leafage of rests and balms and salutary influences." These words were certainly alluring to the northern reader tired of the seven-month winters and yearning for a new land of adventure, where inexpensive or free property could be easily acquired.

The state of Florida wanted to lure new residents, so in 1855, the state created the Internal Improvement Trust Fund. The state had more than 21 million acres of land to grant to entities and settlers who improved the land through cultivation and drainage or to dredge canals and build railroads to bring eager new settlers. Through several court battles after the Civil War, the fund found itself deeply in debt. From Philadelphia appeared Hamilton Disston, who offered in 1881 (the same year the Deweys arrived in Florida) to purchase 4 million acres of submerged and low lands for $1 million in cash. The state accepted the offer, and the Internal Improvement fund was saved. It made Disston the largest private landowner in the world.

Settlers could also purchase land through Florida's Internal Improvement Fund, through the railroad and drainage companies, or be granted land through the Homestead Act. The 1862 Homestead Act allowed settlers to claim 160 acres of public land for free if they resided on the land for five years and improved it by farming or clearing the land for cultivation. If they did not want to wait the five years, settlers could purchase the homesteaded land for $1.25 per acre after living on it for six months and improving the land through cultivation and construction of a home. Union soldiers could also reduce the five years by the amount of time they had served in the army during the Civil War.

The first stop on the itinerary for many a northern visitor or new resident was Jacksonville. Situated a few miles from the coast on the St. Johns River, the city had seen many different flags fly over its streets, including Spanish, French, British, and even the short-lived Republic of Florida. Jacksonville changed hands several times between the Union and the Confederacy during the Civil War; during the Reconstruction era, the city experienced a resurgence in prosperity. Northern doctors began to recommend the Jacksonville area to winter-weary northerners as early as the 1870s; some well-known people who sought its winter warmth included Mary Todd Lincoln, President Abraham Lincoln's widow, who visited in 1875; Henry M. Flagler, the Standard Oil Company founder who hoped to help his ailing wife's health; and Harriet Beecher Stowe, famed abolitionist and author of *Uncle Tom's Cabin*, who took up residence in the nearby town of Mandarin. Stowe wrote in a letter from January 1872, "We begin to find our usual number of letters, wanting to know all this, that and the other, about Florida. All in good time, friends. Come down here once, and use your own eyes, and you will know more than we can teach you."

As the Deweys had made the decision to venture southward, the first question to arise was what would become of their beloved Bruno. Their earlier experiment with trying to give Bruno away had failed miserably, so the thought of such a breakup again was disheartening. Birdie wrote, "I began to think a way would open, and my heart felt lighter than it had at any time since we first began to talk Florida. If we could have Bruno with us, I no longer dreaded going to a land which, in my imaginings, had appeared to be teeming with unknown dangers."

After Fred spoke with the railway agent, Bruno was allowed to partake in the grand adventure, but it would be difficult and not without additional expense for Bruno's passage. The biggest challenge in the long train journey to Florida was the numerous changes and transfers along the way. Because Bruno would be traveling in the baggage car, Fred had to see that Bruno was safely transferred to the next train at each stage of the journey. Birdie lamented that friends and neighbors had little confidence in their great

Florida experiment, and with Bruno to boot! She felt that most of the people in their circle of friends fully expected them to return within a year, realizing the foolishness of their adventuresome ways.

As the train journey started southward, Fred went to the train car where Bruno was traveling to see how the dog was faring on the journey. He found Bruno to be frantic and howling. But as soon as Bruno caught site of Fred, all was well—no doubt Bruno had thought that he was once again being sent away to live with strangers. The fate of Rebecca (the Dewey's Blue Maltese cat) was something that bothered Birdie deeply. Taking a dog on such a journey to Florida was enough of a folly, but a cat would have been impossible. Birdie knew that, and she had given Rebecca to a neighbor who had done some domestic work for the Deweys. Birdie reflected on her difficult decision: "I bade her a tearful goodbye, and carried away an ache in my heart that I sometimes feel yet. Some day I hope to go across into cat-heaven and hunt her up. Then she can be made to understand why I was seemingly so hard-hearted as to go off and leave looking mournfully after me on that sad day so long ago. Maybe she knows now; I hope she does."

As the train chugged some 400 miles southward from Salem, Illinois, toward Lookout Mountain in Chattanooga, Tennessee, the first transfer went well. Subsequent transfers were equally as successful. They boarded the "sleeper" train for the final 450 miles of the journey as they reached Jacksonville, just a few weeks before Christmas 1881. A cold snap had arrived with the Deweys, and the balmy weather they had dreamed of was just an illusion. Birdie wrote, "How startling, then, to feel our features pinched by nipping breezes as we stepped from the cars at last in the Sunny South! True, as we passed residences on our way to the hotel, we saw green trees and blooming flowers; but where were the balmy airs that in our dreams were always fanning the fadeless flowers in this Mecca of our hopes?"

They settled into their Jacksonville hotel, welcomed by a roaring fire in the lobby, with Bruno staying in his kennel in a downstairs area. Birdie did not mention the hotel's name, but the finest hotels at that time were the St. James Hotel and the Windsor Hotel; it is doubtful, though, that Fred and Birdie could have afforded such luxurious places. Their stay in Jacksonville was short, as Fred had a friend living farther south in St. Augustine. Although the two cities are well connected today by a leisurely thirty-five-mile drive via highway, the route in 1881 was quite different. The Deweys and Bruno boarded a steamer in Jacksonville for the trip upstream on the St. Johns River. Even though it may seem to be a shorter distance to take the ocean route to St. Augustine down the coast, sailing ships made for ocean passage were

quite different than the steamers built to ply the calm river waters. Uncertain winds, high seas and sudden storms made ship travel on the ocean perilous at times. There was also no road or highway of any significance between the two cities, and such a wagon ride would have been long and tedious.

The Deweys enjoyed the ride upstream on the St. Johns River, and Bruno also seemed to enjoy his first ride on such a craft. Fred and Birdie visited Bruno many times during the journey, as he was required to stay on the ship's lower deck. Their destination was the small town of Tocoi, called "Decoy" by many, a settlement that had sprung up because of it being directly west of St. Augustine and situated on the St. Johns River. The steamers docked at the wharf, where the train met arriving passengers. From there, the Deweys boarded the tiny St. Johns Railroad, a narrow-gauge railway owned at that time by William Astor (of the wealthy New York Astor family) for the fifteen-mile jaunt over to St. Augustine on the coast. Birdie recalled, "There was no one about when we boarded the train; so Bruno followed us into the passenger coach, crept under the seat, doubling himself up like a shut knife, and, totally effaced by the time the conductor came around, rode first-class for once. It seemed such a treat for us all to be together as we journeyed, that our short ride across from 'Decoy' to the coast stands out in memory as the pleasantest part of the journey." Today, Tocoi is all but abandoned, made obsolete when Henry M. Flagler extended his Florida East Coast Railway directly from Jacksonville to St. Augustine. All that remains of Tocoi are some wood pilings where the train depot and wharf once stood, as well as a few abandoned dwellings.

After a few days with Fred's acquaintances, the Deweys secured a boardinghouse room in St. Augustine. It must have been terribly ironic that in this vast, unknown place of Florida, they were in America's oldest city. The Deweys spent two weeks enjoying the scenery and getting used to Florida and its different sensations. Even Bruno had some learning to do about waters and creeks that looked pleasant:

> *He promptly made a dash into one of the creeks as the tide was flowing in, and took a big drink. He was warm with running, and the water looked so inviting that he had taken a number of swallows before he tasted it. Then his antics were most comical. He snorted and shook his head till his ears flapped again, and rubbed at his nose, first with one paw and then with the other. After that one lesson he never again drank from a strange pool or stream without first tasting it very gingerly, then waiting a few seconds to make sure of the after-taste. But if he objected to the taste of salt water, he found no flaw in the feeling of it.*

# The Deweys and the South Florida Frontier

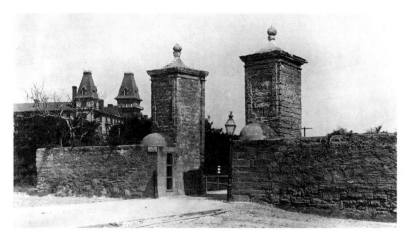

GATES OF ST. AUGUSTINE. The Deweys began their Florida journey in Jacksonville, arriving a few weeks before Christmas 1881. From Jacksonville, they traveled by steamship down the St. Johns River to St. Augustine. *Courtesy Library of Congress.*

The inspiring ocean breakers and the beach were loved by all three. Having been raised in interior states, undoubtedly the vastness of the ocean, with its smells of salt and crispness of breeze, alluded to the paradise the Deweys so sought. Although she remarked that "[s]ome days were quite chilly," most days in December were warm enough for their summer clothing. St. Augustine, with its strong Spanish influence in architecture and design, had made it seem as if they were in a foreign country. Alas, Christmas arrived in this strange land, a green Christmas like they had never experienced: "It was a very strange Christmas to all three of us. The air was pleasantly warm, and green things, with roses and other flowers, were in sight in all directions." They had wished to celebrate in the "Old Cathedral" (the Cathedral Basilica of St. Augustine) built in the 1790s. But the balmy salt air combined with good food found them fast asleep early in the evening. They awoke on Christmas morning to the sound of little boys marching down the street, banging their new Christmas drums.

And so, the first few weeks of the great Florida experiment had passed, but the vacation holidays were fast coming to an end and life's realities would soon emerge. Birdie wrote, "As soon as Christmas had passed, we, with that feeling of having turned a corner, common at such times, began to hasten our preparations to go on South." Now the effort at earning a living and creating a home in the vast Florida wilderness was to begin, and with it new hardships and hurdles to be overcome.

# The Dreamer of Dreams

As the Deweys' Christmas holidays were coming to an end in St. Augustine, a cloud of uncertainty remained regarding where they would pioneer in Florida. They looked at several pieces of land in St. Augustine and the vicinity, but the irony of "pioneering" in the oldest city in America was something that did not escape Birdie: "We had inspected various tracts of land around St. Augustine, but had not found anything to which we felt particularly drawn. It seemed rather odd, too, to come south intending to pioneer, and then settle in or near what was the old sergeant at the Fort assured us was the oldest city in the Union."

So the Deweys decided to venture deeper into Florida's wilds. Exactly where they tried pioneering remained a mystery for months. In *Bruno*, the story is related how the Deweys wanted to start an orange grove, so it seemed logical that they had relocated to somewhere in the middle of the state, since South Florida was a vast swamp unsuited for citrus groves. A massive land reclamation project was underway to drain lands in the middle of the state through Hamilton Disston's purchase of more than 4 million acres of land in 1881. Many new communities and towns were springing up in what is today called Central Florida, and citrus farming was on the minds of many settlers as a way to fortune and a gentleman's life. In the 1880s, the Orlando area and its many communities and lakes were referred to as "South Florida." What is called South Florida today was a vast unsettled swamp with no more than a few hundred settlers in the Everglades region.

From a research standpoint, it was a daunting task to have to search through every town and county in Central Florida to see if the Deweys once owned land there. The only clue in *Bruno* as to the name of a place was Birdie calling a town "Lemonville." There is no town named Lemonville in Florida today, and a search of old maps failed to turn up any towns that were ever called Lemonville. There was, however, once a town called "Mellonville," which is now a part of Sanford, Florida, named after Captain Charles Mellon, a war casualty of the Second Seminole War. Sanford was another dream community of a large landowner, in this case Henry Shelton Sanford, a United States diplomat, who purchased more than 12,500 acres of land to start his "Gate City of South Florida," a citrus empire and transportation hub to the emerging areas surrounding what would become the town of Sanford.

The other clue as to their settlement point was that in *Bruno*, Birdie stated that she had a "relative" living in the area who recommended that they look at land in Central Florida, where he was living. Tracking down the name of the "relative" was another puzzle to be solved; he is never mentioned by name in *Bruno*. It was not known if the relative was just a fictional character added to make the story more interesting.

The answer to both questions emerged after months of research and quite unexpectedly. Searching through book stacks in the Florida Collection at the West Palm Beach Library, a volume entitled *Orange County* by William Fremont Blackman was found. Written in 1927, the book provided Orange County and Orlando's history and biographical information on influential citizens. Blackman related the history of several towns, including a small settlement called Zellwood, which Colonel T. Elwood Zell founded in

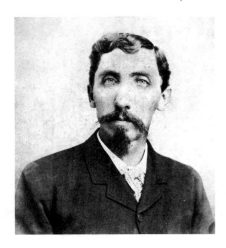

1876. Zell was a retired Civil War officer and a publisher of a well-known encyclopedia of the time, *Zell's Cyclopedia*. Richard Goldsborough Robinson was Zellwood's co-founder. That name did not mean much,

R.G. ROBINSON. Birdie Dewey's cousin and Zellwood's co-founder, Richard Goldsborough Robinson, a grandnephew of Zachary Taylor, encouraged Fred and Birdie Dewey to purchase farmland in the Orange County settlement of Zellwood. *Courtesy Florida Archives.*

43

until the book revealed his heritage: Robinson was Zachary Taylor's grandnephew. And thus Birdie's "relation" was revealed—Robinson and Birdie were first cousins. Mary Louise Taylor, Robinson's mother, was Eliza Taylor Spilman's sister.

Zellwood is about thirty miles from Sanford, so was Zellwood the mythical Lemonville of Birdie's writings? That question remained. Tracing the route to Zellwood explained in the book *Bruno*, the Deweys left St. Augustine and took the train to Tocoi, where they could catch a steamer to the lake region around Orlando. From Tocoi, the Deweys sailed up the St. Johns River in a steamer and spent a few nights in Eustis as they waited for the message to be delivered to Robinson that they had arrived.

The ride from Eustis to Zellwood was described by Birdie as a "half day journey" by wagon. The roads at that time were dusty, rutted dirt roads at best, so travel was slow. Soon they were in Zellwood, "the little inland settlement surrounding two small lakes for which we had started." The lakes Birdie mentions are Lake Maggiore and Lake Minore, just north of Zellwood.

Her writings reveal why she probably did not name her cousin in *Bruno*: "It had been long years since we had seen the relative who was living there, and childish memories did not tell us that he was the most visionary and unpractical of men...we took his word for a number of wild statements and decided to buy and settle there." Orange County's land transaction records revealed that on February 1, 1882, the Deweys purchased ten acres of land for $100 from Charles Sellmer, with R.G. Robinson as witness. And thus, the Deweys had their first Florida homestead.

ZELLWOOD PAMPHLET. Colonel T. Ellwood Zell founded Zellwood, Florida, in 1876. Zellwood served as home for the Deweys in 1882 and early 1883. *Courtesy www.archive.org.*

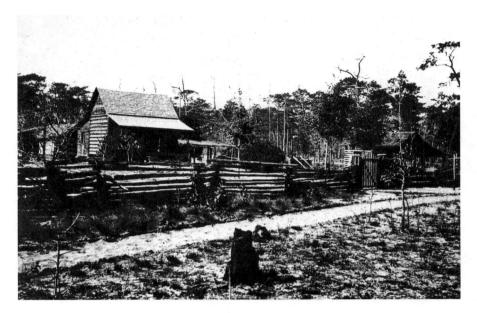

CENTRAL FLORIDA LOG CABIN. After purchasing ten acres, the Deweys initially lived in a log cabin in Zellwood. Birdie called it "pioneering with a vengeance." She furnished the shanty with books, pictures, bedding and clothing. *Courtesy Florida Archives.*

As Fred was building their house in Zellwood, they stayed in a log cabin, what Birdie called "pioneering with a vengeance." She describes it thusly: "This shanty looked decidedly uninviting, but the alternative was a room in the house of our relative, a full mile away from our place; so we decided in favor of the shanty. It was built of rived boards, slabs split out of the native logs. It had one door and no windows. In fact, it needed none; for the boards lapped roughly on each other, leaving cracks like those in window-blinds, so we could put our fingers through the walls almost anywhere."

The tiny cabin had basic furnishings, but the Deweys' possessions soon arrived from Jacksonville: her beloved books, a few pictures, their bedding and their clothing. She wrote, "We had two wooden chairs, and a bench which we put to various uses. When these things were all in place, and our books arranged on boards which were laid across the rafters overhead, we felt as snug as was Robinson Crusoe in his cave."

An adjoining ten acres of land was purchased by Birdie's sister, Clara, and her husband, George Andrews, in September 1882. It is not believed that the Andrewses intended to relocate to Zellwood, but rather that they bought the land as an investment, or perhaps as a loan to Fred and Birdie, with the Andrewses holding the deed. In December 1882, the Deweys purchased the

ILLUSTRATION FROM THE BOOK
*BRUNO*. Byrd Spilman Dewey's
1899 book *Bruno*, published by
Little, Brown and Company,
became a bestseller. The story,
about the Dewey's dog, chronicled
the young family's 1880s Florida
life and adventures. *Private collection.*

land from the Andrewses, so that they now had twenty acres in Zellwood, more than enough acreage for a substantial orange grove.

With hired help, the Deweys cleared pine trees and stumps so that the orange grove dream could begin. Their plan was to raise vegetables on part of the land to provide an immediate income while the orange trees matured. The Deweys sold part of the land as a right-of-way for the train route southward from Eustis. That train route was parallel to the present-day road, the Orange Blossom Trail.

The nearest large town was Eustis. This town has gone through many name changes but was finally christened after the large lake nearby, named for General Abraham Eustis, who saw service in the Seminole Wars. Eustis is eleven miles from Zellwood via trail, which meant a wagon ride of a few hours. The town had a large hotel (the Ocklawaha Hotel), a telegraph service, steamer service on the lake, a grocery and a hardware store.

One of the humorous stories Birdie related happened during the cottage construction in Zellwood. Fred had come back to the cabin from the cottage

building site without his tools. Birdie asked him where they were, and Fred replied that he left them under the new house, wrapped up in an old coat; he thought that was better than lugging them home each evening. That evening, Bruno did not return from his evening run. A restless night was had in the Dewey household, sick with worry as to Bruno's fate in the wilds of Florida—had he met his fate with an alligator or some other misfortune?

The next morning, they heard a rustling at the front door. Birdie opened the door, and Bruno trotted in happily, looking well rested and with a voracious appetite. Fred and Birdie greeted him with big hugs, which amused Bruno. In spite of being tired from the restless night, Fred proceeded over to the building site but returned after a few minutes to tell Birdie that he had solved the mystery of Bruno's disappearance. Under the house by the tools were Bruno's telltale paw prints around the tools. He had slept there during the night to protect Fred's tools: "He had watched Fred arranging and leaving the tools, the while making up his own mind that it was an unwise thing to do, and evidently deciding to see to it later."

The newly built cottage in Zellwood was outfitted with furniture and a "chicken park" to supply eggs and poultry. The Deweys were not shy about trying "camp food." She wrote that they tried roast opossum, stewed gopher tortoise and alligator. Birdie's description of alligator steak is worth noting: "When the steak was cut the meat looked white and fine-grained, like the more delicate kinds of fish. When cooked it was very inviting, being a compromise between fish and the white meat of domestic fowls. We enjoyed it very much and were loud in our praises of alligator steak, but we didn't want any more! I cooked the rest of it for Bruno, and he ate one more meal of it; then he struck. We have since heard that most people who try alligator steak have the same experience. A first meal is thoroughly enjoyed, but one not brought up on such a diet never gets beyond the second." Her account of alligator meat may be one the first literary accounts of the long-running joke that says alligator meat "tastes just like chicken."

The Deweys settled into their pine woods cottage in Zellwood and started their pioneering efforts. They had enough money to cover their expenses for a year, but that first season, they discovered that the land they purchased was not at all suited for vegetable growing. As she put it, "[O]ur whole crop of vegetables would not have filled a two-quart measure." There was no more money to wait for the orange trees to mature, which takes five to seven years. They began to realize that the orange grove estate dream was not going to happen, as they had followed her cousin, the "dreamer of dreams" who had not led them to a place where their own dreams could be realized.

As Fred conducted business in Eustis, a friend and local merchant, referred to only as "Hawkes" in *Bruno*, learned of Fred's skills as a bookkeeper. He offered Fred a position as a bookkeeper in his Eustis store. Fred thought about it on the ride home to Zellwood and discussed it with Birdie. It seemed like the solution to their financial dilemma. She was dismayed at the thought of Fred returning to office work, as well as giving up so soon on their little orange grove estate: "We had seen it in imagination blossoming as the rose, a quiet little nest, far from the madding crowd. And now to abandon it at the beginning and go back to village life, it was leaving poetry for the flattest of prose."

The Deweys decided to try living in Eustis. Fred secured three upstairs rooms in a house in Eustis, and she wrote, "We do not like living in the homes of other people, so as soon as possible we made arrangements for two town lots, and put up a little cottage." And from this description of the lot purchase, the mystery of Lemonville was solved. Land records show that the Deweys bought two town lots in Eustis on July 7, 1883, from Guilford David Clifford. Clifford was one of Eustis's leading citizens, having platted large parts of the town and running the general store. Clifford is undoubtedly the "Hawkes" that Birdie mentions in *Bruno* for whom Fred had agreed to take a position as a bookkeeper. The Deweys bought Lots 9 and 10, Block 26, in the Clifford Division of Eustis.

The first thought was the remote possibility that this little cottage could somehow still exist. Through the help of Louise Carter, historian at the Eustis Historical Society, old Eustis plat maps were located; the maps revealed another startling find—the Dewey house had been located on Dewey Street. Was this just a coincidence, or was the street name connected to Fred and Birdie? Carter explained that it was the tradition of the time to name the street for the first settler living on the street, in this case the Deweys. The cottage, however, had not survived the century that had passed and had been demolished sometime in the 1960s. But Dewey Street remains, and the story of how it was named is now known to town historians.

It can be speculated as to why Birdie essentially shrouded the name of Eustis as "Lemonville." The best hypothesis is that she did not wish to harm her cousin's feelings or shine any negative light on the town of Eustis, a place to which she returned to many times over the years, and Central Florida in general.

They sold the Zellwood land and settled into their life in Eustis. Fred returned to office work, and Birdie was once again keeping house in a small village, much like the life they had left in Salem. One adventure did await them, though: an invitation to attend a ball with the president at that

time, Chester A. Arthur. In *Bruno*, this episode is presented as a "ball with the Governor," but the evening with President Arthur is undoubtedly the event in question. In all likelihood, they secured the invitation through Mr. Clifford, being an influential businessman. President Arthur was in Florida hoping to improve his ailing health. The president's party set forth in April 1883 for a Florida respite. President Arthur arrived in Jacksonville via train but did not stay the night as smallpox had broken out in the city. He carried on via steamer to Sanford, where he stayed for a few days. He then fished for several days in the Kissimmee River. The party did not venture farther southward, as the telegraph lines stopped there and the president needed to keep contact with Washington, D.C.

President Arthur returned to attend the ball at Sanford but was sunburned and not in a social mood. Fred and Birdie had left Eustis aboard a steamer to attend the ball but were caught in a storm on the lake and arrived too late to attend the ball; rooms were scarce in Sanford, and they shared a room with another couple left stranded after the storm. They never did get to meet President Arthur on his Florida jaunt.

Their time living in Eustis was short. Birdie explained, "In spite of our snug little home in Lemonville, we never felt quite settled there. We were not built for village life. Country life is good, and city life is good; but in a village one has all the drawbacks of both, with the rewards of neither. So it was not long before we resolved on another change."

The Deweys sold the Eustis cottage for $450 to William Gable on December 1, 1883, thus ending the first chapter of their Florida pioneer life. They decided to return to St. Augustine, where they rented a cottage in 1884, to see what properties they could purchase. Fred continued to work in Eustis for a few weeks, sometimes leaving Birdie in Bruno's care in St. Augustine. Birdie was no doubt at this time submitting articles for publication in the popular magazines and periodicals of the time, and she painted souvenirs for St. Augustine gift shops. She also painted small scenes of the area such as lighthouses and beaches. One great-great-grandniece commented that if it were not for her writing and painting, they would have "starved." Examples of her paintings have not been found. But nothing in St. Augustine seemed to be to their liking as far as property. Once again, they found themselves in Tocoi to take the train back to Jacksonville, to see what the Florida metropolis could offer. What awaited them there, at fate's hand, brought them a sadness that they felt for the rest of their lives, as well as led to events in history that to a large part contributed to their being so lost to time.

# "Night in a Long White-Draped Room"

With the properties in Zellwood and Eustis sold, and finding nothing interesting in St. Augustine, the Deweys found themselves in Jacksonville in the middle of the busy 1884 tourist season. No cottages were available for rent, so the Deweys found a boardinghouse that suited their needs. They had a long room with a river view, and Birdie had a "lamp stove," a small kerosene device that could be used for both cooking and illumination. Fred found a job with Thomas V. Cashen, a leading businessman who had one of the largest lumberyards in Jacksonville. After a time, they rented a cottage. Jacksonville's tourist industry was booming at this time, and they remained in the cottage until the next year. East Jacksonville was their next stop, and the city directory showed them living on Mattie Street. Fred's position was listed as bookkeeper at Wallace and Lasher, a prominent lumber business. By this time, another pet had found its way into the Dewey household, a cat named "Catsie" that Birdie called "the very moral of Rebecca."

In 1885, Birdie was twenty-nine years old and Fred forty-eight. Finally, the Deweys came to know the joys of parenthood with the birth of their first child, a baby girl, whom Birdie only refers to as "Little Blossom" in *Bruno*: "Sometimes Little Blossom lay across my knees, the firelight mirrored in her thoughtful eyes, her pink toes curling and uncurling to the heat. Sometimes she lay cradled in Fred's arms, while he crooned old ditties remembered from his own childhood."

Childhood disease was prevalent at that time, and infant mortality rates were high. Birdie had been worried about Little Blossom as she did not

seem to be growing as she should. Outbreaks of yellow fever, malaria and even smallpox were common in Jacksonville, and such diseases proved to be especially dangerous to infants and children. The Deweys rented a summer cottage in East Jacksonville along the seashore to try to avoid disease and have fresh air for the baby. Fred commuted to his job, and Birdie, Bruno and Little Blossom enjoyed the seashore. It is possible that the seashore cottage they stayed in belonged to Mr. Cashen, who had a cottage on the beach to live in while he supervised construction of a nearby hotel.

But fate, in its sadness and finality, had its sights on Little Blossom: "It is night in a long white-draped room. One end of it is lighted by a lamp having a rose-colored shade. In the middle of the lighted end stands a crib. A little white robed form lies within. The pink light so simulates a glow of health that the mother, sitting beside the crib, bends low, thinking the little breast heaves. But no. The waxen cheeks chill her lips." Little Blossom had died, scarcely after her life had begun. It is a gripping description of losing a child, the only child ever to be born of Fred and Birdie. She stated in a 1930 letter, "I had wished a house-full of babies," but it was not to be.

The question of whether Little Blossom's story was a true one remained a puzzle for months. At that time, there was no requirement to register a death with the county or state; no records were found of the baby's death, and searching was hampered by not having the child's first name. It was difficult to imagine that such a sad story was related in *Bruno* if not true. Everything else in the book was supported by the paper record—dates, land transactions and other unnamed persons whose identities were revealed through investigation.

And so it was with Little Blossom, too. The authors followed each of Birdie's brothers and sisters using census records and other demographic databases. In looking at Florida death records, a W.M. Spilman was found, born in 1854 and died in 1926 in Jacksonville; it was known that Birdie's brother, William Magill Spilman, was born in 1854. A call to the cemetery revealed that William Magill Spilman, Birdie's brother, was buried in the Greenlawn Cemetery (the former Dixie Pythian Cemetery) in Jacksonville. But the cemetery representative had another startling finding: buried next to William in an unmarked grave in the infant section was an Elizabeth Dewey. Little Blossom had been found.

Named for Birdie's mother, Eliza, Birdie had the infant's remains moved to the Greenlawn Cemetery, which did not open until 1918. The book *Bruno* again proved to be an accurate and biographical account of the Deweys' life. The fact that the Deweys had no children who survived is greatly responsible

for why they have been forgotten by Florida historians. There was no one to tell their story and ensure their place in Florida history.

After Little Blossom's passing, Birdie returned to their home in East Jacksonville. She wrote, "No crib stands by the fireplace; no tiny garments are spread out to air. All is orderly as in the years that now seem so far away. She sits with book or needle. The book falls to her knee, the work slips to the floor; tears steal down her cheeks."

The death occurred at a time when there were no support groups and no mental health counseling, only the comfort from each other and their faith. Of course, Bruno was a great comfort, but the years were catching up to the beloved dog. She wrote, "We sit alone, we three, in the twilight—Fred and I, with Bruno at our feet—talking of the future. We speculate on the beyond, hoping it will not be the conventional Heaven, with harps and crowns. We long for a sheltered nook, near the River of Life, where we and Little Blossom can resume the life so happily begun here, going over to the Happy Hunting Grounds to get Bruno, and to the Cat Heaven for Rebecca and Catsie. Then, our family circle complete, we would settle down to an eternity of HOME."

Bruno died as well, not long after Little Blossom. This double blow left the Deweys hopeless and discouraged. Their orange grove dream was gone, they had lost their baby and they had lost their comforter, protector and friend. And thus, the chronicle of *Bruno* ends.

They undoubtedly considered a return to their northern home. They had endured six years in Florida that had brought much hardship. But the Deweys could not give up on Florida. There was something yet to find, a jewel shining to the south that awaited them.

# The Lake Worth Country

It was 1886, and a new chronicle was to begin. This part of the Dewey story was discovered through Birdie's book *From Pine Woods to Palm Groves*, a serialized novel. This book would have never been rediscovered had it not been mentioned in an old newspaper article. The August 27, 1909 edition of the *Maysville Public Ledger* published an article titled "Maysville's Gifted Daughter." It noted, "Mrs. Dewey has a serial story now appearing in *The Florida Review* entitled *From Pine Woods to Palm Groves*."

The only library that had a complete set of the *Florida Review* was the Jacksonville Public Library. It was not known how many parts the series had or what years of the Dewey journey it covered, as the material was not indexed or available through the Internet. It turned out to be an eight-chapter book. The book opens with an author's note: "The reader who is familiar with *Bruno* and *The Blessed Isle* will see that *From Pine Woods to Palm Groves* is intended to bridge the interval between them." The book provides a fresh account of pioneering life in Palm Beach County, one that had gone unnoticed by historians for more than a century. But its time had come to be uncovered and the wonderful story to be retold.

The book's first chapter provides a glimpse into Birdie's ideas on the power of one's surroundings on the spirit: "When all else fails, Wisdom commands: Seek changed environment. Go somewhere and begin anew. Change affects the spirit through every sense. Hope and courage follow revived interest. Body and mind are made whole. Life begins again from a new starting point, and there appears a new Heaven and a new Earth."

And so the Deweys made a most daring decision: venture southward to the great frontier that lay to the south. "All Southern Florida bordering the ocean ever seemed to us a land of romance, fanned by mysterious, spice-laden breezes." They sailed to this mysterious place and were among the first to discover the paradise of South Florida long before the rest of the world, as well as to be witness to the creation of a world-famous paradise and playground for the elite.

In February 1887, Fred and Birdie collected together their "household gods," those few belongings that make a house a home: books, souvenirs and pictures. But what was this mythical place, this "Lake Worth Country," that was to become their paradise? Even in prehistoric times, the people who lived in the area that would become Palm Beach County did not number many souls. The earliest inhabitants, the Ais, Tequestas and the Jeagas, were Indian tribes who had lived on the coastal barrier islands for thousands of years. They, too, had an eye for fine real estate, enjoying the oceanfront with its breezes and plentiful bounty from Lake Worth, the then freshwater lake that runs twenty-one miles from present-day Palm Beach Gardens southward to Boynton Beach. These earliest inhabitants left behind immense oyster shell mounds containing their artifacts and sand mounds containing their dead. The Spanish decimated the indigenous tribes and brought disease that killed many Indians, save a few taken away as slaves and some who may have intermarried with the Seminoles. Most of their shell mounds were eventually trucked away for road fill.

A new people were soon to arrive on the scene. General Andrew Jackson drove thousands of Creek Indians from Georgia into the Spanish Territory of Florida, and skirmishes with the Indians began in about 1814. Much speculation exists as to how the term "Seminole" originated. The Spanish referred to the Indians as the *cimmarón*, which meant "wild men" or "runaway men." The tribes then began to refer to themselves as the as *yat'siminoli*, which means "free people" in the Creek language, and eventually the word "Seminole" came into use. The Seminoles lived and thrived in the Everglades; they became difficult to control, especially when they began harboring runaway slaves from southern plantations (the "Black Seminoles"). The subsequent two Seminole Wars were meant to oust the inhabitants and send them westward to reservations in Indian territory, but despite thousands of deaths on both sides, hundreds of Seminole Indians remained tucked away in the Everglades by the time the wars had ended in 1858.

The war's remnants were many, including the naming of the prominent lake adjacent to the coast that soldiers named "Lake Worth" in honor of General William Jenkins Worth, who had led many battles in the Second Seminole War. The Seminoles called the lake Hypoluxo, which meant

"water all around, no get out," indicative that no inlet led to the ocean. Charles Pierce, an early pioneer, noted in his memoirs that Hypoluxo was the Indians' word for an island, meaning that an island was surrounded by water. For this reason, the Pierce family named their island in Lake Worth Hypoluxo, a name that remains.

After Florida became a state in 1845, the federal government had the enormous task of surveying the land. In 1858, thirty-one-year-old William J. Reyes and his chainmen, Paul Sabata and Gaspar Corrints, were assigned the contract to survey a large portion of what would become the northern half of Palm Beach County. At that time, surveyors used 66-foot-long chains to measure the land. An acre is exactly ten square chains, and a mile is eighty chains long—the familiar 5,280 feet. They conducted the first detailed survey of the area from October 28 through November 3, 1858, and the resulting map is the earliest detailed look at the area, before drainage and filling so altered the topography. The vast swamps and the evergreen sand pine forests along the western shores of Lake Worth were hand-drawn on the linen map. It was from this map that the settlers could claim or purchase their homesteads.

The surveyors found a landscape that looked very different than today's coconut palm–lined beaches. Only the native subtropical vegetation abounded: cabbage palms, saw palmetto, cocoplum, sea grape, live oak, slash pine, sand pine, mastic trees and mangrove covered the lands and shoreline. The low areas were swampy with sawgrass and cypress, while in the higher

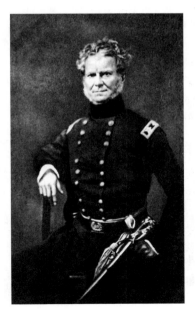

dry lands, pine trees and oak abounded in the flatwood forests. Wildlife was there too: deer, raccoons, foxes, squirrels, panthers, opossum and even black bears enjoyed the plentiful foraging areas that the wilderness and swamps provided. But those calm waters also bred mosquitoes that knew no limits; one surveyor in his field notes labeled it "miserable boggy country."

GENERAL WILLIAM JENKINS WORTH. Fred and Birdie Dewey journeyed south though the Florida wilderness to the "Lake Worth Country" in February 1887. The coastal body of water was named Lake Worth in honor of General William Jenkins Worth, who led troops in the Second Seminole War. *Courtesy Library of Congress.*

Certainly a few sailors had been shipwrecked along the coast over the centuries, but no one of European heritage had actually attempted to live in the Lake Worth region until the 1860s. Author Tim Robinson compiled many pioneer biographies in his 2005 book, and much of the early pioneer information was gleaned from his research. The first European to live on the shores of Lake Worth was Augustus Oswald Lang, who was born in Germany and had some agricultural education. On the 1860 census, Lang was living at St. Lucie. In 1861, he was employed as an assistant lighthouse keeper at the newly built Jupiter Lighthouse. His political beliefs were with the Southern states, and he became a Confederate sympathizer. Lang and his comrades disabled the Jupiter Lighthouse and several other lighthouses and reported their efforts to Florida governor Madison S. Perry. Lang then joined the Confederate army on January 27, 1862; he subsequently deserted on August 18, 1863.

Remembering the Lake Worth wilderness, Lang returned and built a shack from driftwood and palmetto fronds on the barrier island known today as Palm Beach, about where the old Bethesda-by-the-Sea Church is today. He did not own the land in Palm Beach but rather was a "squatter"; Lang did file for a homestead farther north near Fort Pierce.

Lang was discovered in 1866 quite by accident by Michael and George Sears, who were sailing home to Biscayne Bay from Sand Point (Titusville); a storm had created a tiny inlet as water was rushing into the ocean. Sears sailed into Lake Worth through the inlet, proceeded down the waterway and noticed Lang standing on the shore. Lang asked if the war was over, which it was. Sears also ended up homesteading in the area, after seeing the immense beauty of the unspoiled landscape.

The next person on the scene was Charles Moore. The April 5, 1900 *Lake Worth News* reported, "He came from Chicago where he got into some trouble that made it necessary to seek another abiding place without delay." Moore made his living by being a beachcomber, walking up and down the beach looking for shipwrecks and cargo lost from ships. Today's beachcombers might find a few shells and some sea glass, but Moore found many treasures, including $8,000 in gold in a trunk, according to the newspaper's account.

Whatever washed up on shore was put to use. In the 1896 *Lake Worth Historian*, Marion Dimick Geer noted, "Trunks containing ladies' clothing, too, and Mr. Moore assured us he wore trimmed underclothes for some time, having no wife to utilize them." Moore bought 129 acres on Palm Beach and took over the small cabin that Lang had built on Palm Beach; he also homesteaded 80 acres on the west side of Lake Worth, north of the present-day downtown West Palm Beach.

# The Deweys and the South Florida Frontier

Hiram F. Hammon filed the first formal homestead claim on Lake Worth on July 28, 1873. Settlers had begun to enter the area from northern cold climates, ready for a pioneer life that was not easy. The nearest store and doctor were 135 miles away in Titusville, a trip of one to two weeks, and mail service was sporadic at best. The second homestead claim was filed by Hannibal D. Pierce, who had been the assistant lighthouse keeper at Jupiter; from his lighthouse perch he could see the shimmering water that was Lake Worth to the south. Pierce filed his claim farther south than Hammon, on an island in Lake Worth that he named Hypoluxo.

A very influential pioneer, Elisha N. "Cap" Dimick, arrived with his extended family in 1876 from Michigan. He built the first structure that could truly be considered a "house," complete with glass windows and built from lumber shipped down the Indian River from Jacksonville. The house became the fledging community's center, witnessing many dances and holiday celebrations. Soon, Dimick added eight rooms to the house, and the community that called itself Lake Worth had its first hotel, the Cocoanut Grove House, opening in 1880. (The city that today is known as Lake Worth was not incorporated until 1913 and has no relation to the earlier Lake Worth Post Office located on the barrier island of Palm Beach.)

The hotel could be named as such because of a fortuitous event that had occurred just two years earlier. On January 9, 1878, the Spanish brigantine *Providencia*, headed for Cadiz, Spain, shipwrecked off Palm Beach carrying twenty thousand coconuts from Trinidad. Two pioneers, William M. Lanehart and Hiram F. Hammon, made a salvage claim against the ship and began selling the coconuts to settlers, not so much for food but for planting. They hoped that thriving coconut plantations could provide a cash crop for the pioneers, one that was in demand and shipped well across vast distances. There were certainly a few coconut palms here and there along the coast started from coconuts that had washed ashore and taken root, but this cargo allowed thousands of the fast-growing trees to be planted. The old saying is, "The coconut—seven years from nut to nut." Lanehart ended up being the highest bidder at auction for the floundered ship, paying $20.80 for the ship and its entire cargo.

Lanehart wrote, "I was greeted by the mate of the vessel, with a bottle of wine and a box of cigars, as a sort of olive branch. There were 20,000 coconuts, and they seemed like a godsend to the people. For several weeks, everyone was eating coconuts and drinking wine." Many settlers bought the coconuts for the two-and-a-half-cent asking price, and they planted coconuts along the coastal areas, but especially on the barrier island that soon named itself.

Dimick had spelled coconut as "cocoanut," as was popular during the Victorian era. This spelling lives on today on Palm Beach's Cocoanut Row

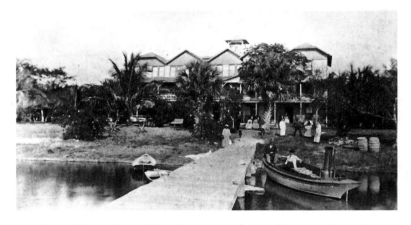

COCOANUT GROVE HOUSE HOTEL. The Deweys stayed at the Cocoanut Grove House, owned by Elisha N. Dimick. The Cocoanut Grove House, named for the twenty thousand coconuts gleaned from an 1878 shipwreck, was opened in 1880 and served as the Lake Worth area's first hotel. *Courtesy Florida Archives.*

and in Cocoanut Grove south of Miami. The post office had been known as Lake Worth, but the settlers decided that their new coconut palm-filled paradise needed to become a named settlement. Palm City was submitted to the U.S. Postal Service in January 1887, but residents were notified that another Florida town had already chosen that name. Fittingly, a tourist from up north, Gus Ganford, had another suggestion, "Palm Beach," after all the coconut palms. And so in November 1887, Palm Beach emerged from the tropical jungle.

This was the landscape along Lake Worth as Fred and Birdie made their decision to venture to the Lake Worth Country. The first step in this new beginning was to secure a homestead. At the federal land office in Gainesville, Fred filed a homestead application on December 27, 1886, for two government lots, and in February 1887, the journey southward began. Birdie wrote, "The Lake Worth Country was almost as remote as the moon. The railroad ended at Titusville, and, from there, we sailed in a schooner large enough to carry both us and our effects." The trip from Titusville to the Lake Worth inlet took seven days, something that could be driven today by car in three hours. They sailed down the Indian River, following the broad, calm waters with its many sandbars. But the last nine miles of the trip to Lake Worth saw them sail out the Jupiter Inlet into the ocean waters, as Jupiter was the terminus point of the Indian River: "We sailed into Lake Worth Inlet from white-capped seas to a ruffled sound bordered with shores of primeval forests and thickets. There was a semi-occasional clearing where toy houses

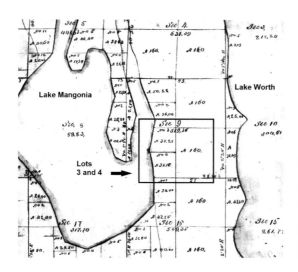

SURVEY MAP. On December 27, 1886, Fred Dewey filed a homestead application for two government lots. The land, outlined on this 1859 survey map, had a high ridge running north and south through the property. *Courtesy Bureau of Land Management.*

tip-toed to peep over what looked like immense bushes of red roses, but which proved later, on closer inspection, to be the glorious, ever-blooming hibiscus."

They stayed at the Cocoanut Grove House, spending a few days on the east side. She wrote, "It was a new Florida we had discovered. True, there were a few families living there; but we felt ourselves to be, none-the-less, real discovers." They set forth to inspect the property they had secured at the land office in Gainesville. Fred's homestead claim was for two government lots in Section 9, Township 43 South, Range 43 East, which bordered a lake to the west, the entrance to the Everglades. When land bordered water and therefore had an irregular shape, it was surveyed as a "government lot" for claim purposes. The land, which totaled seventy-six acres, was located about one mile inland from Lake Worth, and the property's western edge was located on the inland freshwater lake known as Sunset Lake, today's Lake Mangonia. Very detailed information on the claim, the land and the improvements the Deweys made to property is in the National Archives. The homestead claim file provided pertinent details on life at their first Palm Beach homestead.

It is quite possible that the Deweys were living farther west in Palm Beach County than anyone else at that time. It certainly would have been more prudent to purchase property along Lake Worth, but the land farther west was essentially free to the claimant. The property's middle was about where Twenty-fifth Street is located, and its eastern point was about where Tamarind Avenue is on a modern West Palm Beach map. Lake Mangonia's shoreline was much farther east than it is today, as it was dredged and filled in the 1950s to build a major roadway. It was on this isolated spot that the Deweys built a small home of charm and beauty in the wildest woods of South Florida.

# The Hermitage

The land they secured was unique for South Florida, as it had a high ridge running north and south through the property. They started clearing the land in February 1887 and had cleared the home site and two acres by May. Sand pines, oak trees and white sand covered the property, with saw palmetto and other Florida forest plants as groundcover. She wrote, "By climbing a tree on the wooded hill we also had a fine view of the Atlantic Ocean, with its passing sails and smoke-stacks." Because of the good view, they chose this hill to build their cottage. According to the federal homestead file, they occupied the property on May 20, 1887, first pitching sleeping and cooking tents and building a chicken park before they began building their own cottage.

The lumber for the house was hauled to the building site in April, and Fred built the house, with a carpenter assisting, in only eighteen days. This cottage is depicted in the background of a picture taken in 1923 of the city incinerator. There in the distance, tucked under the sand pines, a small cottage is visible that matches the description provided in the homestead file of a twenty-two- by twenty-five-foot cottage with windows on each side.

Birdie named the small cottage the Hermitage to signify its remote location. This small cottage and its description provided key clues in deciphering Birdie's pen names she used for magazine writing. Authors write under pen names for a variety of reasons; often in the nineteenth century, female writers submitted articles under a man's name to increase chances of being published.

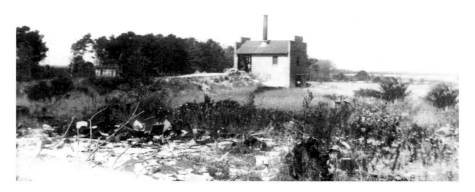

LITTLE COTTAGE IN THE WOODS. The Deweys built a twenty-two- by twenty-five-foot cottage, which they affectionately referred to as the Hermitage due to its remote location in the pine woods. This view shows the small dwelling in later years, tucked under the pine trees on the left of the photo. *Courtesy Florida Archives.*

A biography published in 1917 furnished a complete listing of works published under her real name. Through libraries and antiquarian dealers, copies of all her works were located and compiled, except one: a short story with a title that made the elusive hunt that much more alluring and mysterious. The work's title was "Who Seeks, Finds."

The authors returned to the Historical Society of Palm Beach County archives to see if something had been missed in the Dewey file, and indeed something had. Upon opening the folder, the document at the very top was "Who Seeks, Finds," complete with a hand drawing on the cover by Birdie. The story is a fairy tale with the moral that you find whatever you look for, good or evil. It had been published in pamphlet form, as she often did with her short stories. The inside cover stated that it was published courtesy of the Century Company, which published many leading periodicals of the time, including *Scribner's Monthly* and *Century Illustrated Monthly*. If the story had been published before, why did months of searching fail to find it?

An Internet search of a few of the story's keywords along with the title found a link that showed the full text of the article's first sentence. With a click of the link, the article appeared with its byline, Judith Ray. A pen name had been revealed. The article was published in 1895 in *St. Nicholas*, a popular children's magazine of the time published by the Century Company. However, extensive searches in periodical and magazine databases failed to find any other articles written by a Judith Ray. Additional searches, this time using just the first name Judith, uncovered several articles written by another Judith. This time it was Judith Sunshine. A "Ray of Sunshine" had finally

shone on the quest to unearth Birdie's pen names after more than a century of being hidden. Undoubtedly several more remain to be discovered.

The clincher that this was Birdie's writing was that in the short story "At Other's People's Convenience," the Judith and Julius characters made their entrance into the literary world, some nine years before *Bruno*'s publication. There were three articles published in the *Christian Union* that provided wonderfully detailed glimpses into the Hermitage, the four-room cottage they had built. She also used the initials J.S. in several articles and letters that appeared in the *Lake Worth News*, a local West Palm Beach newspaper.

The Hermitage, with its design and refinement, stands in stark contrast to the depiction of pioneer life in most accounts of early South Florida. Most often, families are portrayed living in palmetto shacks with dirt floors. Although some did build palmetto shacks while a more substantial house was being constructed, rain and vermin could too easily penetrate the walls, and such a shack offered no protection against storms.

Birdie's first known article was published in November 10, 1887, in the *Christian Union* and explained how they had camped that summer in tents: "It will rain occasionally, even in the best regulated climate, and although a good tent will not leak, there is a dampness about the inside air that can not only be felt, but smelt, and also tasted. Its flavor is like mildewed mold." Florida's summer humidity must have been quite a challenge while living in a tent during the weeks it took to build the Hermitage, as they had moved to the property at the beginning of Florida's rainy season in May. The wood and building materials came from Jacksonville. She described the Hermitage thusly: "Our little home consisted of four rooms below; a living-room, and a bed-room in front connected by a large archway, and back of these were dining room and the kitchen. There was an attic above the two front rooms where we stored various odds and ends; the piles of papers and magazines that are always with us; also spare sails; and other boat tackle."

In the April 5, 1888 article from the *Christian Union*, Birdie described in great detail how they constructed the furniture, with Fred completing the carpentry and Birdie the upholstery. A feature in all the Dewey homes was that of built-in furniture, and being a small home, it made an efficient use of the limited space. She provided detailed instructions on how to make a built-in sofa and construct sideboards and bookcases that were built on each side of a window to give the effect of a bay window. She states "Our furniture was all home-made, the 'good man of the house' having a taste for such work. To those who must depend on outside skill I would like to say, do not have any dealings with those mechanics who will tell you that a thing is *impossible* because *unusual*."

Frank Lloyd Wright, the famous architect and designer, was also a proponent of built-in furniture, so Birdie was ahead of her time in using this innovation.

Birdie decorated the house with white drapes and red carpets on the wood floors, which had been oiled to make them look like hardwood. They also had an outdoor worktable where she took her "work-basket," which contained her sewing, reading and writing materials. The nearest house belonged to an elderly horticulturalist, Reverend Elbridge Gale, who lived about half a mile away to the northeast. Gale served as one of the witnesses for the homestead application confirming that the Deweys did reside on and improve the property.

So began life in their pine woods home. On the two acres they had cleared, they planted tropical trees and plants such as guava, pineapple, sugar apples, tamarind, coconuts and avocado. According to the homestead claim, they made no attempt to grow "crops" in the sense of vegetables. To earn a living, Fred worked in many different jobs, helping out with businesses as they opened. On weekdays, he went over to Palm Beach on the east side of Lake Worth and helped out with accounts with the few businesses there, picked up the infrequent mail or did a bit of fishing or hunting. With his extensive carpentry skills, he also worked on many buildings, and he painted structures as well. Being close to a large freshwater lake must have meant plenty of mosquitoes; often South Florida pioneer books and stories will devote entire chapters to the agony of mosquitoes. This passage is the only mention of mosquitoes in *From Pine Woods to Palm Groves*: "An Isle of charm, mosquitoes, sandflies, redbugs, makeshifts and charm. The charm predominated. It was first and last; but all the other things were just as real."

For Birdie, such an isolated life must have been difficult, but she was pleased that Fred seemed to be filled with energy in the emerging community. Her days were devoted to the usual household tasks, attending to the chickens and, of course, much reading and writing. It is hard to imagine that she sat there in such a desolate place, composing her stories and correspondence, in complete isolation where thousands of people now live. She received few visitors, as most women would not have sailed alone across Lake Worth and then walk the mile inland through the sand pine forest. Her words truly convey the loneliness: "Now and then there was a neighborhood picnic, or a Sunday spend-the-day visit, with long weeks between during which I, having no daughters, never saw a woman's face except the reflection of my own when, for very loneliness I carried my sewing to sit before the dressing-table where I could lift my eyes now and then and 'play' that the reflected image was a busy companion." She waited for Fred to return each evening, listening for his familiar "Bob-White" whistle as he walked up the hill to the Hermitage.

Such long, reflective days did have a positive effect on her spirit and the great losses she had endured. Fred found her two kittens to once again bring pets into the Dewey household; they also spoke often of Bruno and how he would have loved the sand pine woods and have been their protector in such a place. But Little Blossom was another matter: "Of our Little Blossom we never spoke. That was a pain too deep; and each hoped that the other might succeed in the impossible task of forgetting." The two kittens provided companionship for Birdie, and they were christened Catty Meow and Kitty Winks. She wrote of them, "If spirits do return to make sure their earthly friends have not forgotten them, I hope the shades of the two enchanters who are responsible for the sweetened solicitude of my endless days, were often near to see the effects of their magic."

Such a land of adventure offered one of the benefits of coastline life—shipwrecks laden with cargo that seemed to appear just when needed. All in the community shared in the bounty—bags of flour or boxes of candles, although mundane items took on a "romantic interest as trophies from a wreck." Summer weather also brought a beachcomber's treasure: turtle eggs. During the late spring and early summer months, sea turtles swam ashore, dug sandpits on the ocean beach and laid hundreds of eggs in each nest. These eggs were much prized by the pioneers for baking and cooking. But such eggs were harvested with great caution—they were also the black bear's favorite food. Many pioneers had stories of an encounter with a black bear in search of turtle eggs.

To allay Birdie's fear of being so isolated, Fred often left the shotgun with her. One time, however, he asked to take it with him as he had seen many ducks on the lake. Fear filled her being without the gun, but she absorbed herself in books and writing, until a feeling overcame her: "[A]ll at once I was disturbed by that indescribable feeling of being stared at." Only the screen door had been latched to allow a breeze in the house. Upon looking up, she saw standing and staring a Seminole Indian, complete with turban and calico shirt. The Seminole addressed her: "Where man?" Birdie did not want to let on that she was alone in the house, so she simply replied, "Man busy." The Indian requested to use the small boat he had seen at the lake in back of the property to cross over toward the Everglades. The boat belonged to local hunters and not to the Deweys, but Birdie felt it best to let him take the boat. The Seminole Indian said that he would bring the boat back in the morning.

She had hoped this would end the conversation, but each stood fast. "I racked my brain for a way to terminate the trying situation. All at once an inspiration came to me to say to him: Goodbye!" This was what the

# The Deweys and the South Florida Frontier

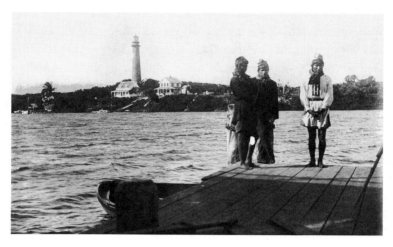

SEMINOLE INDIANS AT JUPITER LIGHTHOUSE. During the late 1800s, the Seminole Indians traded with the pioneers living along the coast. The Jupiter Lighthouse, constructed in 1860, is seen in the background. *Courtesy Library of Congress.*

Seminole was waiting to hear, and he walked back down the hill. In her words, she felt "like a stopped clock" and fainted, only to be revived by the concerned clawing and licks of the two cats. She demanded that Fred never leave her alone again without the gun.

Being such an untamed wilderness, it was filled with game. To supply some fresh meat for the table, Birdie took to her own hunting expeditions to shoot small game such as squirrels or quail. "Fred became so proud of my skill as a Diana, that it added greatly to his enjoyment of our game dinners." She described in detail how Fred had seemed dismayed with his meals and left one day with only a jelly sandwich. Birdie set out that morning and bagged some quail for the evening meal. She prepared the quail, "done to a turn" as she described it, served on toast.

Obtaining groceries and food was a challenge, and sometimes dinner even fell from the sky. Fred thought a chowder would make a fine noon meal, and all ingredients were at hand, except the fish. He was too busy repairing an oar to go fishing; she reminded Fred of the famous cookbook quote of "catch your hare"—the first step of a recipe is to have your game at hand. Then an osprey appeared overhead with a large fish in its talons, being pursued by another osprey wishing to rob it of its catch. In the struggle, the fish was dropped a few feet from Fred. A few minutes later, it was scaled and filleted, ready to be added to the chowder.

Although there were two local stores where basic supplies could be had on the barrier island (the Brelsford store and the Hendrickson store),

the shipments arrived at the mercy of the weather. As fall set in with its northeast winds, entering the narrow, dangerous inlet to the ocean became more treacherous. Schooners could make it as far as Jupiter on the Indian River, but then the ships had to turn out to sea to sail the final nine miles of their journey to Palm Beach. At times, the schooners tacked back and forth, waiting for more favorable winds; once the sailors ended up consuming all the supplies aboard; they had to return to Jacksonville for another load. When supplies were low, the stores first ran out of flour and kerosene. After the kerosene was out, Fred and Birdie turned in with the chickens, with no light to read or write in the evening. The next day, the mail boat did manage to make it through the inlet, and Fred returned to the Hermitage with two weeks' worth of mail. "We built up a fire of pine wood knots, and sat down on the floor in front of the stove, with its fire-doors open, our treasures of mail in our laps, devouring the words until the backs or our heads began to feel cooked." Fred's trip over to Palm Beach the next day yielded boxes of candles from a ship that had dumped its cargo in the gale.

The isolation, loneliness and anxiety began to take a toll on Birdie's nerves, making her ill for several days at various times. Several friends in Palm Beach urged them to make a temporary home on Palm Beach during the week while Fred was working. Thus, the "Camping Place" became another unique Dewey home. The Camping Place was actually a large boathouse on the eastern side of Lake Worth that was closer to the settlement in Palm Beach and offered more company for Birdie. The boathouse had an inside deck above the water that served as a "living room" and a small enclosed loft where two cots would just fit that served as their bedroom. She wrote, "The boat-house life was now to satisfy another dream; for it was in many ways like house-boat living. The ceaseless lap-lapping of waves, the aids to easy housekeeping in the ability to throw or sweep overboard every sort of trash or 'clutter' and to watch at ease the movements of fish, or other water-creatures while busy at indoor tasks."

During this time, Fred was employed as a carpenter in Palm Beach; houses were sprouting up as new settlers from the north were beginning to discover this paradise. This absence from the homestead was also noted in their homestead affidavit. There were rules about how long a person could be absent from their claimed property, and Fred did note the absence, citing his work in Palm Beach and that it would be too far to trek home to the Hermitage each evening. They returned each weekend to the Hermitage to do laundry and bake bread for the week. The cats came along to the boathouse, but they gave the chickens away. Planning lunch was something easily done in the

boathouse: "The first thing I did was to drop a baited hook from between the railings of our indoor gallery and catch a mess of pan fish for the noon meal. I soon found that it was an easy matter to tie hand lines there and let them do the fishing for me while I attended to the little daily tasks of this primitive housekeeping."

Church services were held in the schoolhouse, and a traveling pastor made his way around Dade County through the Home Missionary Society. Being raised in the church, it was quite amusing to the Deweys that they were in need of a missionary, but the Lake Worth Country was as unsettled as any place missionaries needed to venture. The congregation met on an irregular basis in the summer, whenever the pastor was in town. During these weeks, Fred and Birdie longed to return to their pine woods haven: "The sweet, refreshing sleep and keen appetite produced by the effect of the pine-breath was noted every time we slept at The Hermitage." They began to realize that the Hermitage was just too far from Palm Beach to be truly a fulfilling home. She remarked, "Fred, we are just like two of these big wood-ants: always frantically dragging things around from one place to another."

The reliance, too, on the east side for supplies meant bad weather made them even more isolated. At times, they could not make the mile-long lake crossing for days, so they attended to household matters such as making guava jelly, diving into their extensive library or making clothes. Birdie wore muslin frocks or dresses that she had made, while Fred wore "negligee shirts," a pull-on shirt with buttons only about half way down the front, and seersucker coats. Fred had created a sort of hanger from cutting hoops from a wooden sugar barrel; traditional metal hangers rusted too easily in the humid salt air climate. To be successful at pioneering meant tackling problems with creativity: "In pioneer life, the one who commands the situation, is not the man of means, or the one who has been enervated by a life of luxury; but it is the capable, resourceful man who is looked up to by all who finds him rising to meet each emergency and overcome its difficulties."

Finally, the winds had died down enough for Fred to venture over to the stores in Palm Beach to see if any supplies could be had. No schooner was able to enter the inlet, so all that was available was supplies that had washed up on shore—flour, candles and bales of cotton. Birdie asked, "Did you find any kerosene at the store." Fred replied, "Not a drop. Everybody is out. Our boats are still unable to get into the inlet." Once again, the last of the kerosene was used to "devour" the papers and letters that Fred had brought over since the mail boat had arrived. Then they had to make do with the candles for evening light, "the light of other days" as Birdie referred to it.

---

## *HENDRICKSON'S*
# Palm Beach Store.
### Dimick & Hillhouse's Old Stand.

## All Kinds of Country Produce for Sale.

#### All New Goods of the Very Best Quality to be Found,

## At Prices that Cannot be Beaten.

### Goods Delivered on Either Side of the Lake.

If you want First-Class Groceries equal to the Best in the Northern Markets let Us serve you.

### U. D. HENDRICKSON, Proprietor.
### PALM BEACH AND LAKE WORTH, FLORIDA.

---

HENDRICKSON STORE ADVERTISEMENT. Fred Dewey worked for U.D. Hendrickson, whose store was located at the northern end of Palm Beach, near the inlet. The general store carried supplies for the pioneers, including groceries and hardware. *Private collection.*

These difficult pioneering days left a permanent impression on Birdie, as she always remembered these times when she turned on an electric light for reading in future times.

Fred had many jobs as new businesses and opportunities presented themselves. In October 1888, Fred was the quarantine officer at Jupiter, as reported in the *Florida Star*. He inspected ships for sick passengers who might be carriers of malaria or yellow fever. These diseases were not fully understood at the time and were thought to be contagious; the mosquito's role in spreading disease was not yet known. While Fred was stationed at Jupiter, Birdie stayed at the Cocoanut Grove House, so she was not completely alone for so long. Fred's next job was at Captain Uriah Dunning Hendrickson's store in Palm Beach, which was located near the inlet. This was quite a bit north of the Brelsford store, which stood where the Henry Morrison Flagler Museum is today. Hendrickson owned the store and two schooners, the *Bessie B* and the *Mary B*, which took produce from local farms north to Titusville and Jacksonville and brought back supplies to his store. Fred listed his position as bookkeeper in his homestead application and cited that as one of the reasons why he had to be away from the Hermitage homestead at times.

But the back and forth travel from Palm Beach to the Hermitage would soon come to an end. And the new place they were to create was a home of books, culture and respite for all of Palm Beach, the realization of a dream and the personal paradise where Birdie penned her most famous works.

## *The Blessed Isle*

T he Deweys began to look for a new Lake Worth Country homestead, one closer to Palm Beach. She wrote, "Although there was a degree of pleasure heretofore unknown in our quiet days at The Hermitage, just our two selves and our lovely kits, we never once changed our plans of making another, less isolated home. We looked up and down the West Shore of the Sound, pricing the various pieces of land which were available, and weighing the advantages and disadvantages of each."

The "West Shore" referred to the area that today is West Palm Beach, which did not exist in 1890, when the Deweys secured their land on the shores of Lake Worth. The isolation that she experienced at the Hermitage was something that she did not want to experience again. Waterfront property along Lake Worth was what most people wanted as the lake acted as a "highway" for the settlers. The west shore ideally received the southeast tradewinds that prevail most of the year, as the lake water cools the ocean breezes. The newspapers of the time did not refer to town names such as Palm Beach; events occurred on the "East Side" or the "West Side" of Lake Worth.

The land they purchased was a portion of a government lot along Lake Worth. The lots along the water south of present-day West Palm Beach were homesteaded by members of the Lanehart/Lainhart family in 1876. George Lainhart homesteaded lot one, while older cousin Benjamin Lanehart (they spelled their names differently) homesteaded Lots 2 through 5; Benjamin's property totaled 130 acres. Benjamin built his palmetto shack about where Olive Avenue and Flamingo Drive in West Palm Beach are

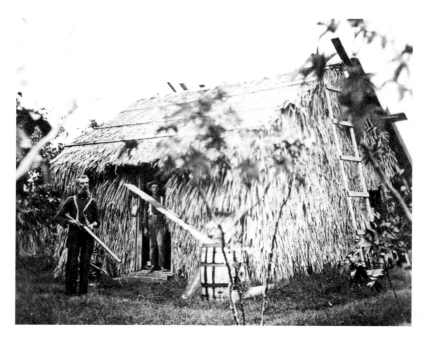

BEN LANEHART'S PALMETTO SHACK. Ben Lanehart, one of the earliest pioneers on the west side of Lake Worth, stands outside his palmetto shack. Fellow pioneer Abner Wilder is standing in the doorway. *Courtesy Historical Society of Palm Beach County.*

today. He cleared some land and grew sweet potatoes and pumpkin, and the homestead was granted by the federal government on August 1, 1883.

Lanehart began to sell his land in parcels. In 1888, George Bristol bought a five-acre portion of Lot 3 and built a house on the natural ledge near the shoreline. The lot was about 220 feet wide and 900 feet long. He had built a long dock out into Lake Worth, so larger boats were able to dock at the property. At that time, the word "dock" was not used to refer to what is called a dock today; rather it was called a wharf.

Of the five acres, the west three acres had been cleared, and two of those acres had been planted with pineapples. The land surrounding the house that Bristol built was covered with oak and sand pine trees, or what was called "spruce pine" at the time. One feature that attracted the Deweys to the property was that the deed had riparian rights, which meant they owned the waterfront rights. "Thus we became the happy possessors of The Blessed Isle," she wrote. "It was not really an island, but, like The Hermitage, it was across the water from everything, and the only way to go anywhere, was by boat. We looked across to the settlement, and, on clear days, could signal to the other side. Out on the wharf, we had a fine view up and down the Sound,

WHARF AT THE BLESSED ISLE. The Blessed Isle's long wharf extended far into Lake Worth, allowing larger vessels to dock at the Dewey home. *Private collection.*

of points running out from both shores, and of islands of various shapes and sizes, covered with palms and other growth."

The Deweys paid $600 for the five acres and the small house on the property, and they signed the deal on January 23, 1890. The meaning of the name "Blessed Isle" was yet another mystery to be solved. She provided a clue at the end of her second book, *The Blessed Isle and Its Happy Families*, as to the origin of the name, by mentioning the "Elysian Fields." In Greek mythology, the Elysian Fields were a form of heaven for heroes and for the brave. The Islands of the Blessed was an island paradise heaven on the western side of the Okeanos River reserved for heroes of the Greek myths. Such a place was a "winterless paradise." Plutarch, the Greek historian of ancient times, wrote, "[W]here the air was never extreme, which for rain had a little silver dew, which of itself and without labor, bore all pleasant fruits to their happy dwellers, till it seemed to him that these could be no other than the Fortunate Islands, the Elysian Fields." Birdie was a student of Greek mythology, and the analogy of the Blessed Isles to the Lake Worth Country was perfect, so she named the estate the Blessed Isle.

The move from the Hermitage to the Blessed Isle began. As she always had to have chickens, Fred put up a fowl house with wire netting to keep out the wildlife that loved nothing better than fresh chicken and eggs. Birdie

began to pack their belongings at the Hermitage, and it was not without bittersweet feelings: "The Hermitage had been so completely our home—so really our own creation, evolved from wildest nature, that it was harder to give up than was any other we had ever left. We had found it an unbroken forest, tied together with wild vines and undergrowth, and we had made it a home blest with a charm of real comfort and beauty."

Fred secured a sloop and hired a few men to help pack their possessions and take the wagon down to the water so their things could be loaded aboard the sloop. Even though the Blessed Isle was about two miles south, there were no roads or trails to take. Last to be packed up were the two cats, which would have scampered into hiding at the sight of strangers. All was loaded on the wagon, and it began its way down the hill, chickens clucking and cats crying out of fear. Birdie walked behind, carrying her most prized possession: a Greek goddess statue she named "Meditation." By twilight, they had reached the sloop, and it was loaded with all the goods, while the cats and fowl had to be towed behind the sloop in a small skiff. As darkness fell, the strong south wind caused them to tack back and forth along the sound for the two-mile ride southward.

As they approached the Blessed Isle, the skipper realized that the low tide and strong winds would not allow the heavily laden craft to dock safely at the wharf. Instead, they anchored the sloop near the channel, got aboard the skiff with cats and chickens and rowed to the Blessed Isle. The cats were freed from their crate and quickly scampered into the underbrush. The men retrieved the food basket, a kerosene stove and a few bedding items from the sloop, as it was nearing midnight. Birdie put together a quick stew for the cold and hungry men.

At daybreak, the men brought the rest of the possessions ashore, and all had gone well. Last to be offloaded were her books; being the heaviest, they had been loaded on the sloop's bottom. The books were loaded on the skiff, and it was making its way toward the wharf when the unthinkable happened: a wave overturned the skiff. "My heart seemed to turn with it, as I saw the boxes of books spill into the waves, sink, then bob up around the boat," she wrote. Books were her most prized possessions, some of which "we wouldn't take a farm for." The books were quickly retrieved and unpacked, left to dry in the sun and dry sand, but the damage had been done: "Their bloated, discolored appearance is still a constant reminder of our difficult and adventurous move to The Blessed Isle."

The Blessed Isle's location finally allowed the connections to civilization that Birdie needed. Even with Fred absent, she could take her work under

TROPICAL SUN MASTHEAD. Guy Metcalf founded and published the *Tropical Sun*, the area's first newspaper. Originally published in Juno, the newspaper moved its offices to West Palm Beach in 1895. Birdie Dewey wrote articles as a correspondent for the *Tropical Sun*. *Private collection.*

the pine and oak trees near the house and see boats passing by, waving to the passengers. Fred could also just dock the skiff or sailboat and be home without the long trek that he had at the Hermitage. The two cats and Birdie settled into this new home, and were a wonderful greeting party for Fred each day as he docked on his return from work in Palm Beach.

Development and change was beginning to take hold in the fledgling community. The area finally had its own newspaper, the *Tropical Sun*, which published from the small settlement at Juno (modern-day Palm Beach Gardens) at Lake Worth's northern end, located at the terminus of the tiny Celestial Railroad, a narrow-gauge railway that ran the 7.5 miles between Jupiter and Juno. Birdie was a reporter and correspondent for the newspaper, but how much or what she wrote is a bit of a mystery. *Tropical Sun* articles did not have bylines, but the fact that she wrote for the paper was mentioned in an article written by its associate editor, Ruby Andrews Myers, for the *Tequesta* journal in 1983.

The house that stood on the property needed its own name, too. Most of the homes in the emerging Palm Beach had names, so the Dewey home would be no different. She stated, "There was a small new house so constructed so that additional rooms might easily be added." It is not known how large that original house was, but what would become the Dewey house was a large two-story wooden structure. An article from the September 30, 1891 *Tropical Sun* mentioned that Fred was receiving a large load of lumber so that he could "add quite largely to his house." If the estate was the Blessed Isle, what were they to call the house? This time, they chose an Italian expression popular at the time as the house's moniker. The Italian expression is *Se non è*

*vero, è ben trovato*, which means, according to the Merriam-Webster dictionary, "Even if it is not true, it is well conceived." So, "ben trovato" became an expression of the Victorian era meaning "well invented," and the house was named Ben Trovato, the first of three Dewey houses to carry the name. The renovations continued into 1892, with the *Tropical Sun* reporting that "Mr. Dewey is making quite extensive improvements at Ben Trovato, adding quite largely to his house, and painting and furnishing the part built last season."

The three known pictures of Ben Trovato taken at the time the Deweys owned it show a striking house that combined several architectural styles of the day, including elements of lake style, shingle style and even some Victorian/Queen Anne elements with the octagonal feature that was most likely added in 1891–92. In an interview, Roger Cope, an architect familiar with early Florida homes, stated that the house could be classified as "Federal" style with tropical elements. He surmised that the octagonal feature housed a formal sitting room on the first floor and a master bedroom on the second. The only photographs of the house's interior are a few in the book *The Blessed Isle* of the porches that were located on the west side of the house. Interviews conducted in 2012 with two people who were in the house long after the Deweys owned it both spoke of its magnificent spiral staircase.

About this time, Fred became a political leader in the community, holding several different positions. In April 1889, he was appointed county commissioner for Palm Beach by the Florida Senate, and in 1890, he was elected Dade County tax assessor and appointed tax collector. It is important to note that today's Miami-Dade County is much smaller geographically than Dade County was in the 1890s. Formed in 1836, Dade County stretched from Bahia Honda Key north to the St. Lucie River, about the size of the state of Massachusetts. Today's Palm Beach County was carved out of the northern end of Dade County in 1909. The county seat had been located in many towns, and in 1888, Dade County residents voted to move the county seat from Miami to Juno, at Lake Worth's northern end. At Juno, workers constructed a courthouse and jail, and publisher Guy Metcalf moved his Indian River newspaper to Juno and renamed it the *Tropical Sun*. There was no easy way to reach faraway Miami other than by sailing or walking the beach, something that took several days.

Being tax assessor and collector meant that Fred had to visit every household in Dade County, figure the land's worth and what the tax assessment would be and then actually collect the monies. Birdie wrote, "In a spacious country, where there is not one single mile of road and no steamboats, this is far from being an easy task, and the time consumed made it a real hardship."

# The Deweys and the South Florida Frontier

BEN TROVATO FROM THE WHARF. The front of Ben Trovato faced Lake Worth. Nestled in the pine woods, the two-story house featured a unique octagonal room on the north end. *Courtesy Historical Society of Palm Beach County.*

When Fred was between tax assessing and collecting trips, Fred and Birdie worked together on the massive tax books. In that era of no computers or calculators, the only technology to which they had access was an "adder," a clockwork mechanism that could be used to add single columns of figures. "As we neared the end of making the set of tax-books, we were both full of eager thrills to see if they would come out even." Once the tax book was finished, two copies had to be made by hand. The authors searched for a copy of the tax book, but all three copies have been lost to time.

The 1890 tax collecting trip was uniquely recorded and documented because several passengers had agreed to accompany Fred on his tax collection route. The events were eloquently captured by Emma Gilpin, the wife of commodities trader John R. Gilpin. From Pennsylvania, the Gilpins explored many parts of Florida and finally found the paradise they sought in Palm Beach. Emma Gilpin was a gifted writer and kept journals and wrote beautiful letters to relatives back home. These treasures of South Florida history were saved by family members and donated to History Miami Museum and the Historical Society of Palm Beach County.

Fred arranged for George Potter's sloop the *Heron* for the trip. George served as captain and Ben Potter as first mate, and the expedition included Fred, the Gilpins (with son Vincent) and Elizabeth Marsh, described as "an energetic lady from Chicago." Marsh's role on the trip differs in the Gilpin account of the events and what Birdie recorded. Birdie knew that the trip

would take a month or more, so she had arranged to have "a spinster of mature age" to stay with her, and this woman was to come over on the *Heron*. That spinster was undoubtedly Marsh, who was a "Miss" in the Gilpin account, and an older woman. Birdie wrote, "At the last minute this lady caught the enthusiasm of the cruisers and instead of having her 'big box, little box and band-box' handed out on the wharf of The Blessed Isle, she commanded that they be left in the boat's cabin, where she decided to stay and join the cruising party." Birdie stated that the other passengers were somewhat dismayed by having another on board in such cramped quarters; she quoted Fred as being "floored." In the Gilpin account, Emma stated that Marsh had planned the trip. Which one is accurate cannot be determined. The *Heron* measured thirty-eight feet long and had a fifteen-foot cabin. There were no "facilities" on board, so the friendly group of seven became very familiar with one another.

The *Heron* struggled to get out of the inlet, running aground a few times. Finally at sea, they had a restless night on the rough seas. Fred caught some kingfish, which Ben Potter cooked on a kerosene stove. With coffee, the group enjoyed an expedition breakfast, but the rough seas did not let the food stay down long. In ten hours, with a strong northeast breeze, they had reached Biscayne Bay and sailed to Lemon City, which at that time was much larger and more important than Miami, the sleepy town to the south. Along the way, the expedition party met Commodore Ralph Middleton Munroe, a New York yacht builder who had founded Cocoanut Grove near Miami. The Gilpins developed a lifelong friendship with Munroe, and Vincent Gilpin wrote the commodore's biography in the 1930s.

With no one to stay with her, Birdie was once again on her own for an extended period of time: "I should be left entirely to the society of feathered creatures and the two cats." Birdie decided to keep a diary when Fred was gone, and she wrote each night in the book. She proudly handed it to Fred when he returned, and he laughed at it, saying it was "four-fifths fed the cats and chickens"; she reminded him, though, that "happy is the country that has no history," making him realize that such tame events were good.

Birdie's most immediate neighbor was someone she called the "old German Professor." She does not identify him by name, but land records revealed that Franz Kinzell, an Austrian doctor who had served in the Civil War, had a lot immediately to the south of the Dewey place. At that time, Kinzell was only using the property to grow plants that interested him; he rowed over each day from the Cocoanut Grove House Hotel and tended his property. He brought the mail over to Birdie and purchased needed

THE *HERON*. John R. Gilpin purchased the *Heron* sailboat from George Potter. The Gilpins sailed with Fred Dewey aboard the *Heron* on his 1890 tax collecting trip through Dade County. In this picture, the Gilpin party was headed to Ben Trovato, the Dewey homestead, for an afternoon tea given in honor of the new pastor, Reverend Harding. *Courtesy Historical Society of Palm Beach County.*

provisions for her. Kinzell was a widower, but he remarried in 1892 to none other than Elizabeth Marsh, who had accompanied the *Heron* party on the tax collecting trip.

By this time, Birdie had also befriended the Seminole Indians, who often stopped by to sell venison or other game. Many times, she provided them with a meal and reveled at the amount that some of them could eat. She noticed that they ate the sweet things first, then the meats and vegetables and then finally the bread: "They thought it impolite to leave a crumb; but always, like Jack Sprat and his wife, 'licked the plate clean.'"

Once, when Birdie was buying some venison, she went to her purse and realized that Fred had taken her change, leaving her no money to pay. She said to the Seminole, "Take it back. No money." The Indian replied that she could give him "talk-paper," essentially an IOU that the storekeeper could cash for Birdie. She also related how the Indians traded in the local store: "Each article was paid for as soon as selected, the attendant being obliged to make change for each separate purchase. One striking trait of the Seminole family is the rule of the petticoat. The men make no bargain without consulting Madam Indian and what she says is final. That is quite refreshing when one considers the abject position of the Western squaw."

The tax collecting trip aboard the *Heron* continued, with the group having interesting encounters with the Seminole Indians, touring pineapple fields

and "coontie" mills. The native coontie plant, or Florida Arrowroot, grew under the pine trees on the vast forests and produced a fine white starch that was much valued for cooking; it was one of the few ways to make a living in the Miami wilderness. The final stop was to be the old lighthouse at Cape Florida, but warnings of a coming storm forced the group northward to Biscayne Bay. They went out to sea, hoping to beat the storm back to Lake Worth, but the steady northeast winds slowed their progress. Finally the rain hit, and water poured into the cabin. They could fight it no more, so they turned back. They were looking for the House of Refuge's torches at Fort Lauderdale, their signal that they had reached the New River at Fort Lauderdale (a House of Refuge was a government-run house where stranded or shipwrecked persons were given food and shelter). Instead of the Fort Lauderdale House of Refuge, they realized that they had seen the House of Refuge much farther north in what would become Delray Beach. They had made it as far north as Lake Worth but had not realized it until they turned back south. Eventually, they sailed into the New River at Fort Lauderdale and found a spot where they rested after their ordeal at sea. They waited out the storm there, hoping for a break that would allow them to go northward again. Fred found the remnants of an old stove, and they had a decent dinner on the beach. They remained marooned on the New River for several days, and the men had to obtain provisions at the House of Refuge.

The same weather system wreaked havoc at the Blessed Isle: "For three days kits and I were completely cut off from the rest of the world by heavy wind-squalls with pelting rains." During these frequent cloud-bursts, Birdie tried desperately to save her chickens and their little chicks. Each time she ventured out, she was soaked from head to toe in her long dresses. Then an idea struck: "I got out my bathing suit and so garbed, with its long woolen stockings and a pair of India-rubber sandals, I was ready for unlimited prowls in the rain. It was like having wings, to be rid of the damp, flapping skirts and I told the kits I could understand just how they felt in their close-fitting suits."

Birdie's loneliness during Fred's absence was difficult in a house as large as Ben Trovato. She was "hungry for music," and there was not yet a piano as they had in other homes. Being ever resourceful, she created her own instrument, essentially a kazoo, by wrapping thin tissue paper around a comb: "I went out and sat down on the steps of the front porch to give a concert of one for an audience of two. The cats sat blinking up at me with exactly the bored expressions one sees on the faces of drawing-room victims at an amateur performance." A piano did not grace Ben Trovato until 1892, and the *Tropical Sun* announced that a "fine new piano has been delivered

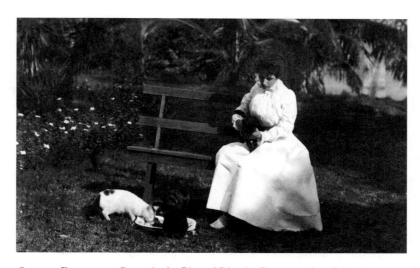

BYRD SPILMAN DEWEY AND CATS. At the Blessed Isle, the Deweys enjoyed the company of Birdie's beloved cats, which became the subjects of her second book, *The Blessed Isle and Its Happy Families. Courtesy Historical Society of Palm Beach County.*

at Ben Trovato, the home of F.S. Dewey. The instrument was purchased in Jacksonville and is an exceptionally sweet toned one."

The *Heron* party again tried to make a run for Lake Worth, but the strong breakers and severe seasickness had them once again returning to the New River. They had to wait another five days to finally get back to Lake Worth. Emma Gilpin wrote, "Captain [George] Potter blows a blast on his conch shell, and immediately we get a response of his brightening light, and soon after a blow from his horn, and a whine from his dog." They knew they were back in Lake Worth. Birdie wrote that Fred seemed to be the only adventurer glad to be back: "To the others all the delays with their endless adventures, only added to the romance of the trip." The Gilpins were to become lifelong friends of the Deweys, and the Deweys are mentioned frequently in Gilpin correspondence.

Fred served his last year as tax collector and assessor in 1892, and on this last traverse of Dade County as an official, Birdie accompanied him on the five-week trip. This time, they engaged U.D. Hendrickson's sharpie sailboat for the trip. The *Tropical Sun* reported, "The sharpie sent a blast from the conch shell over the water at 8:30 in the evening and an exchange of rifle signals was fired. Mrs. Dewey's first 'outside' trip had the most happy attendant circumstances." The trip to Biscayne Bay was smooth, and she reported to the *Tropical Sun* that the trip down was "absolutely perfect—less rough than ordinary sailings. No one was seasick." The newspaper reporter lamented that there was "no crimson glow from Ben Trovato" with the absence of the Deweys.

NEWSPAPER PRESS ROOM IN WEST PALM BEACH. Birdie worked as a correspondent for several Florida newspapers including the *Tropical Sun*, the *Lake Worth Weekly News* and the *Florida Times-Union*. *Courtesy Florida Archives.*

Birdie wrote an extensive article for the *Florida Times-Union*, the Jacksonville newspaper, about the trip that was also carried by the *Tropical Sun*. Her observations of the area and prophecies of what the future held for the Miami area are astounding. She called it the "Biscayne Bay Country" and dismissed descriptions she had read of the area as being uninhabitable because of the mosquitoes, sandflies and rocky soils. Her proof that the area would be successful was how prosperous the Seminole Indians were on the flatwoods just beyond the coastal areas. She wrote, "In the near future the prairies that skirt the Everglades will be one extensive garden of luxuriant tropical fruits and waving sugar cane. This will be the home of vegetable producers and building places for the wealthy people from the North who like picturesque surroundings."

At this time, the Florida East Coast Railway's terminal point was Titusville; in 1892, plans had been announced to extend the railroad another twenty-two miles south to Rockledge. No other plans had been announced for bringing the railroad into South Florida. She foresaw the future here, too: "The railroad is bound to cross this valuable land and bring it within two and a half days of New York City and thirty hours of our metropolis,

PALM GROVE AT THE BLESSED ISLE. Along the Lake Worth shoreline, the Deweys planted a coconut grove. The Blessed Isle gardens included roses, bananas, guavas, limes, mangoes, oranges, avocados and pineapples. *Private collection.*

Jacksonville." She did give an accurate account of affairs as they stood—that most made a living from milling coontie starch or working the occasional wreck on the beach. "The wreck is looked upon as a gift from the Almighty. It is said that during a prayer meeting, when the cry of 'wreck on the reef' was raised and there was a stampede for the door, the minister jumped out of the window and was first at the wreck, and according to their usage, was captain of the wreck and got the lion's share."

The land in Miami and southern Dade County is very rocky, but she foresaw how the rock could be quarried into blocks for building fine homes, which did occur in many homes. She also mentioned the Perrine Grant, given by the federal government to Dr. Henry Edward Perrine in 1838 to create farms for settlers to grow tropical fruits and vegetables on the twenty-three-thousand-acre township. The Seminole Indians drove him from the lands, and at the time of Birdie's visit, only six people were living on the vast pinelands, which today are home to hundreds of thousands of people.

The Deweys sailed on to Key West and then to Tampa, where they caught the train to Sanford. Then it was on to Titusville, where they took a steamer to Jupiter, taking the Celestial Railroad to reach the top of Lake Worth at Juno, where they visited the *Tropical Sun* offices. The sharpie *Gold Dust* sailed them along Lake Worth to the Blessed Isle.

As Fred and Birdie settled back into their paradise at the Blessed Isle and Ben Trovato, the winds of change were gathering that would forever alter their discovered paradise and bring a world to them that could have only been dreamed of. It came on glistening rails and brought the most famous people in the world to their very doorstep.

# *The King Arrives in the Jungle*

As more new residents appeared, the Deweys began to see the possibilities of the Lake Worth Country and the value of its land. With Fred serving as tax collector and assessor, he was able to see the development that was taking place all over Dade County and what land remained unclaimed. This was coupled with the fact that a new type of settler was arriving in Lake Worth. Wealthy northerners who wished to spend a "winterless winter" were now appearing on the lakefront. Robert R. McCormick, a Pennsylvanian who had made his railroad fortune in Denver, Colorado, began to winter at the Cocoanut Grove House in 1884. He wanted to have his own place, so he bought some of Albert Geer's land for $10,000 and built the finest cottage on the lake, Lac a Mer, which endures to this day as the Sea Gull Cottage in Palm Beach. This event was a bellwether for what was happening to land values along Lake Worth, and it was happening very quickly. More well-known people followed, among them Charles I. Cragin, Charles J. Clarke, Frederick Robert and Enoch Root.

Fred and Birdie still owned the seventy-six acres and the Hermitage cottage, but they had the opportunity to make a significant profit on the land. They had not stayed the requisite five years to be granted the homestead at no cost, so in 1891 they paid $1.25 per acre in a cash sale. Some wealthy and prominent Chicagoans took an interest in the property: George B. Swift, who served as the twenty-eighth mayor of Chicago, and James B. Clow, partner in a large plumbing supply distributor and manufacturer that is still in business

PINEAPPLE FIELDS. Early South Florida farmers planted pineapples, which grew well in the sandy soil. Farmers abandoned the plantations after the 1909 pineapple blight decimated the crops, and the land was subdivided for housing. *Courtesy Library of Congress.*

today. Both had winter homes on Lake Worth and wanted to expand business ventures in the area. In January 1892, they bought the seventy-six acres from Fred and Birdie for $2,400.00 and formed the Chicago Pineapple Company, which augmented the Clow family's pineapple farm Windella north of West Palm Beach. Fred and Birdie had their first big profit in land sales and began to look around to quickly reinvest the gains.

First among their purchases was land at the southern foot of Lake Worth; Birdie bought 160 acres from George H.K. Charter on January 29, 1892, for $700.00. The land was bought solely in Birdie's name, perhaps from her writing profits. Fred bought 80 acres along the ridge west of what became West Palm Beach (where Parker Avenue is today) for $1.25 an acre from the State of Florida, and within two months he had sold it for $2,000.00 to John S. Clarke. Fred also bought large land tracts in what became Broward County, buying two entire sections (two square miles of land). The 1,280 acres was purchased from the state of Florida for $1.25 an acre.

With wealthy and well-connected men wintering in Palm Beach and investing in property in the lush tropical landscape, times were changing from the pioneer mindset. These changes set the stage for its star player to enter—Henry Morrison Flagler. Born in 1830, Flagler was a founding partner in the Standard Oil Company along with John D. Rockefeller and was one of America's wealthiest Gilded Age capitalists. Florida became his dream, to be developed with his vast fortune. Flagler had wintered in St. Augustine and Jacksonville as early as 1876, but as Fred and Birdie had already discovered, South Florida had a charm and allure that Northern Florida simply could not match.

COCONUT PALM PAINTING BY LAURA WOODWARD. Artist Miss Laura Woodward arrived in Lake Worth Country in 1890. Her full-color landscape paintings of the South Florida tropics may have encouraged Henry M. Flagler to visit the region. *Courtesy Deborah Pollack.*

Who exactly clued Flagler in on the Lake Worth Country is a question that has been debated by historians for decades. Art historian Deborah Pollack presented an intriguing thesis in her book *Laura Woodward: The Artist Behind the Innovator Who Developed Palm Beach*. Pollack argued that it was Laura Woodward, an artist specializing in landscape scenes, who convinced Flagler to see Lake Worth. Woodward had found the Lake Worth Country in 1890, wanting to paint its exotic coconut palms and other wild scenery such as the Everglades. Woodward had met Flagler in St. Augustine, where she was one of the artists-in-residence at Flagler's Ponce de Leon Hotel. She came to Lake Worth in the summer of 1890, when the Royal Poinciana tree was in full bloom with its garishly red blossoms, and painted all she saw and experienced. With her tropical landscape paintings, she urged Flagler to see Lake Worth and extolled the potential it had as a winter resort. According to Pollack, Laura Woodward's painting of the Royal Poinciana tree is what brought Flagler to Palm Beach in February 1893. Flagler stayed with the Roberts and was enchanted by all he saw. He directed his agents to immediately begin buying land on both sides of Lake Worth. In Palm Beach, Flagler bought the R.R. McCormick and E.M. Brelsford properties to build his grand hotel on Lake Worth. He also announced that his Florida East Coast Railway would expand to Lake Worth.

Flagler's arrival marked an important milestone in Palm Beach County's history—the end of the pioneer era. Now an entirely new game was afoot,

*Left*: HENRY MORRISON FLAGLER. Railroad tycoon Henry Flagler built fine hotels along the route of his Florida East Coast Railway. This statue of Mr. Flagler was erected in St. Augustine at Flagler College as a tribute to his memory. *Private collection.*

*Below*: SEMINOLE HOTEL. George Zapf owned this two-story wooden hotel located at the corner of Banyan Street and Narcissus. The structure burned down in the 1896 downtown West Palm Beach fire and was rebuilt with brick. *Courtesy Florida Archives.*

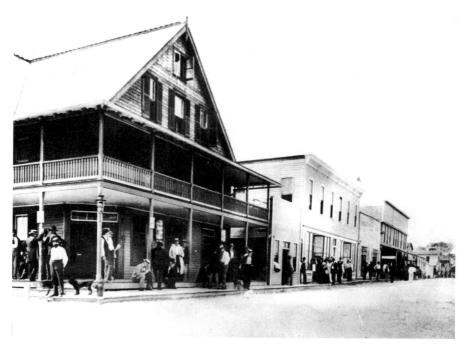

and the area's first land boom had begun. Emma Gilpin wrote in a letter home on March 5, 1893: "The boom is on. Flagler and his rail-men have made the people entirely wild and property is held sky-high. It is whispered that he closed with Dimick [Cocoanut Grove House owner]—that means a fine hotel here next year." Gilpin mentioned that suddenly everything was for sale, including the Dewey property, the Blessed Isle. Flagler's influence was immediately felt. John R. Gilpin wrote in an April 12, 1893 letter to his sister: "Flagler is looked upon as the all-powerful and expectations run high. The railroad is to be built immediately; the surveyor tents are now on the opposite shore." Flagler's railroad extension again gained him thousands of acres of public land. In some cases, Flagler was awarded as much as eight thousand acres of land for every mile of railroad he built. The hotels Flagler built broke even at best; it was selling the lands he received from the state that turned a profit through the following decades.

As Flagler was buying land on each side of Lake Worth, he realized that his dream resort needed a service town to support his planned hotel. Owen S. Porter had homesteaded land along Lake Worth's west side, and Flagler purchased fifty acres from Porter for $35,000 in 1893. Flagler bought other lands from settlers to assemble enough for Palm Beach's service town. Once the land was secured, Flagler hired George Potter to lay out the town grid in August 1893. Local plant names provided the street names in alphabetical order, most of which survive today. East–west streets were Althea, Banyan, Clematis, Datura, Evernia and Fern; north–south avenues were Lantana, Myrtle, Narcissus, Olive, Poinsettia, Rosemary, Tamarind and Sapodilla.

The residents debated what to name this new town. The first suggestion was the town of Flagler, as reported in the April 13, 1893 *Tropical Sun*: "The suggestion to name the new West Side town 'Flagler' meets with popular approval at Palm Beach. Visitors to the Lake next winter at the end of their journey will hear the cry of Flagler!" Even John R. Gilpin was sure that the town was to be called Flagler, as he wrote his sister: "The expectation now is that the Pullman cars will stop at the town of Flagler in November." But Flagler did not want to immortalize himself in this way; rather, a very logical name was chosen, based on the fact that the area was always called the "west side." Residents chose Westpalmbeach, all one word, as the new town's name. It did not change to West Palm Beach until 1896, when two downtown fires caused the superstitious town folk to realize that the first version had thirteen letters.

So once again, a town was beginning to find Fred and Birdie's paradise at the Blessed Isle. The town center was about one mile north of their home. In a

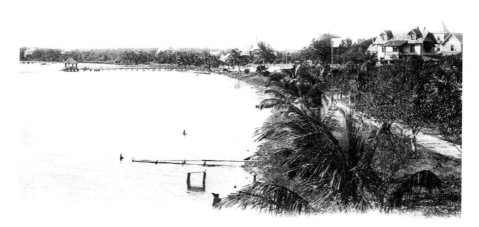

WEST PALM BEACH WATERFRONT. The settlers traversed the waters of Lake Worth, using it much like a highway functioned in other communities. Residents docked at the wharf and would shop and conduct business in town. *Courtesy Florida Archives.*

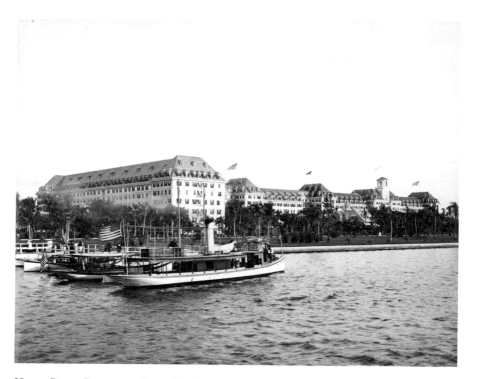

HOTEL ROYAL POINCIANA. Henry Flagler's Hotel Royal Poinciana was opened in February 1894, becoming the largest wooden structure in the world with 1,150 rooms and seven miles of corridors. *Courtesy Library of Congress.*

letter to the editor, published in the December 27, 1900 issue of the *Lake Worth News*, Birdie wrote of early West Palm Beach: "Speaking of our town it is like a dream-city to those who have seen its birth and growth. Fewer than ten years ago, the place where it stands was the haunt of wild creatures who roamed unmolested among spruce pine trees and oak scrub. Later it was a little hamlet of tents and shanties where one waded ankle deep in white sand." The Deweys could easily reach the new town by walking through the pine woods, walking along the shore of Lake Worth or sailing to the wharf at Banyan Street.

In a time when things could be built as soon as land was secured with no thought of zoning, building permits or impact, Flagler immediately commenced with the planning and construction of his hotel and resort. As it served as the inspiration for Flagler's trip to Lake Worth, the Royal Poinciana tree provided the perfect name for the new hotel—it was to be called the Hotel Royal Poinciana, for the magnificent trees that graced the grounds. Ironically, guests at the hotel never saw the tree in bloom as the hotel was only open from January through March and the Royal Poinciana only blooms in summer. The hotel's construction began on May 1, 1893, on a short timeline for completion. John R. Gilpin's letter from April 23, 1893, to his sister noted, "They are working away like bees upon the new hotel—a space 800 feet by 250 feet has been cleared." He continued, "We hear they are going to work on the hotel nights by electric lights. There are evidently great things to be done here this summer—troops of workmen."

As 1893 continued, the Deweys held many grand parties and events at Ben Trovato. The one that was most captured for history was the April 10, 1893 tea party, held just a week after Easter, that marked the end of the "Season," the word that to this day is used to describe the time between Christmas and Easter in Palm Beach. Given in honor of the new pastor, Reverend Harding, more than forty of Palm Beach's best-known winter residents attended the party. This moment was beautifully captured for history, and a wonderful account of the event appeared in the *Tropical Sun*: "Mrs. Dewey invited us to afternoon tea at Ben Trovato. She wanted the gentlemen, of course, and we all went, of course, as did the ladies too. Before us lay the lake, smiling in the sunshine and bedecked in glistening sails. Was it not a picture? It was, and Mr. Russell fastened it in his camera for us." All of Palm Beach's elite families were there, including the Cluetts, Roberts, Gilpins, Cragins, Brelsfords, Clarkes, Bartons, Mulfords, Zapfs and Kinzells.

Fred soon found himself again in public service. The *Bradford County Telegraph* reported that Governor Henry L. Mitchell had suspended the Dade County treasurer and appointed Fred to examine the accounts and report to the county

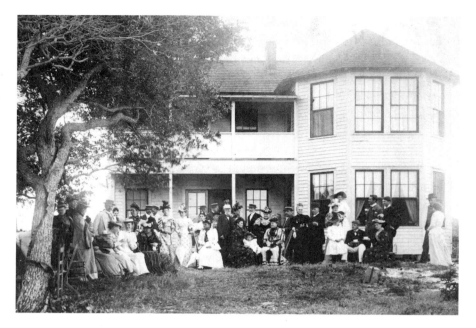

TEA PARTY AT BEN TROVATO. All of Palm Beach's elite families gathered at Ben Trovato for a season-ending tea party given in honor of the new pastor. More than forty are dressed in their wonderful Victorian-era garb, enjoying an April afternoon in 1893. Fred and Birdie are standing at the far right of the photo. *Courtesy Historical Society of Palm Beach County.*

commission. Meanwhile, Birdie was becoming known as a fine hostess for the many parties and events held at Ben Trovato. She entertained important people of the day such as Joseph Jefferson, a well-known actor who brought electricity to West Palm Beach in 1895, as well as with poet and editor Richard Watson Gilder, who was convalescing in West Palm Beach. Ruby Andrews Myers, who was coeditor of the *Tropical Sun*, offered this description of life at Ben Trovato in her *Tequesta* article: "I was a delighted visitor to their home where there were books and book talk. We were all interested in the same things and there was much lively discourse on many topics, but never a word about *Bruno*. Mrs. Dewey did most of the domestic work which she loved, found time to write two or three columns a week for the *Tropical Sun*, visited a little at the hotel principally for the music, I judged, and was a most delightful hostess."

Myers also commented on the ingenuity that the Deweys always displayed from lessons learned in their pioneer days: "There were many ingenious, original contraptions about the house to save steps and fill needs, which she designed and her husband executed. These included a kerosene-lamp-stove arrangement by which her salt-rising bread turned out to perfection." Finally, Myers presents one of the most revealing glimpses into Birdie's

personality: "She had a rare critical faculty—rare in that it was kind—and her bright, optimistic encouragement meant much to her fellow travelers along the road of writing. Small of stature, clear-eyed, curly-haired, with quiet manner, unobtrusive yet possessed of a striking personality, few who have ever known her are likely to forget her. I have never done so and cherish her friendship, satisfying and inspiring."

The year 1894 saw many more significant events. In February, Flagler's Hotel Royal Poinciana had its grand opening, and the first trains arrived in April at West Palm Beach. One of the hotel's first events was to auction lots in the newly platted town of West Palm Beach, and within a few weeks, merchants had pitched tents to sell their wares on Clematis Street. On November 5, 1894, the townspeople gathered and officially incorporated the town, giving West Palm Beach the honor of being the first incorporated town on the southeast Florida coast. The vote was 77-1.

Another milestone in any town's development is its first church. The east side had two churches: the lovely Bethesda-by-the-Sea and a Congregational Church near the Hotel Royal Poinciana. The church by the hotel became a nondenominational one, and the Congregationalists moved their church to West Palm Beach in 1894. Fred played a key role in the founding of that church, the Union Congregational Church, which was located at the corner

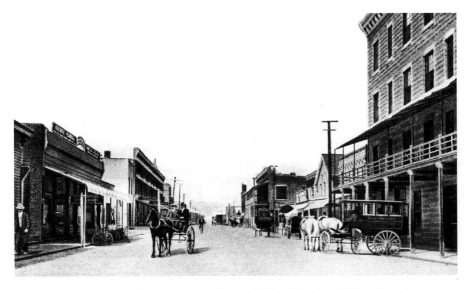

CLEMATIS STREET. Clematis Street was the heart of West Palm Beach's first shopping area. Stores first opened in tents in 1894, and today the street still thrives with shops and restaurants. *Courtesy Florida Archives.*

UNION CONGREGATIONAL CHURCH. Fred Dewey served as the secretary and treasurer of the Union Congregational Church in West Palm Beach. The church, originally located on Datura Street, still exists today in another location. *Private collection.*

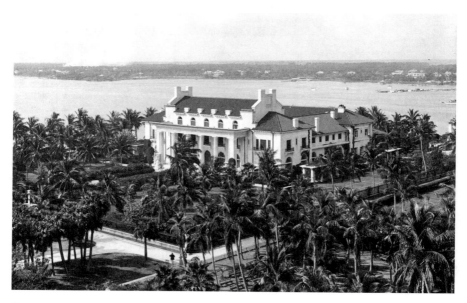

FLAGLER'S WHITEHALL MANSION. Whitehall, Henry Flagler's Beaux Arts masterpiece, has fifty-five rooms. Today, the mansion serves as the Henry Morrison Flagler Museum. *Courtesy Library of Congress.*

of Datura Street and Poinsettia Street (now Dixie Highway). Fred was the church secretary and treasurer, ensuring that the congregation would have a fine building. The church endures to this day, though relocated from downtown West Palm Beach.

Did Birdie worry that the hotel and the tourists would ruin their paradise? No. The Hotel Royal Poinciana brought the culture and ambience that she loved and longed for. Upon attending a concert at the hotel, she remarked, "Only Fred and I, of all present, with souls receptive and attuned to beauty and charm; and with memories of life's real hardships endured and conquered in our pioneering, could enjoy to the full these golden moments in Fairyland which was a dream come true. In our isolation so remote and wild—so denuded of all the luxuries of life's centers—the world had come to us, just as we dreamed it would, bringing everything we lacked and completing what Nature had so perfectly begun."

In *From Pine Woods to Palm Groves*, she never refers to Flagler by name, rather referring to him as the "King": "The coming of the King and Queen of Fairyland and all that their coming meant, had completed the enchantment of our far-away tropical paradise, where the opaline wavelets of its inland sea swing ever to and fro between the palm-fringed shores of Fairyland and The Blessed Isle."

# The Great Freeze and the Orphaned Town

As 1894 was drawing to a close, the October 11 *Tropical Sun* reported that the Deweys "intend on spending the winter at Orlando, where they have leased a house." Birdie wrote, "We had closed the house on our Blessed Isle, and had gone to pass that winter in a little city much further north, up in central Florida; because Fred said he was beginning to hunger for what he called 'A little smell of winter.' He got it." The winter of 1894–95 was one for the history books, and the Deweys were headed right for the "Great Freeze" and its epicenter in Orlando.

They settled into the little cottage and decorated it with books and trinkets to make it feel like home. They were preparing for Christmas, and a surprise present found its way to them: "On the evening of the twenty-second it was just chilly enough to give us the always-wished-for excuse for a little blaze in the hearth." That evening, they heard a small tapping at the door, and a dirty, skinny kitten appeared. Soon the kitten was in the house, lapping at milk, ready to be cleaned up and adopted. For the first time, Fred requested to name a cat, and the white kitten was christened Peter—Peter the Tramp. Birdie wrote this story for the Animal Protective League of New York at the request of Mrs. Myles Standish, the organization's founder, for a fundraising effort.

Peter had a new home and was the one and only "retriever" cat that the Deweys owned—he played fetch much like a dog. Then, on December 29, 1894, the freeze hit. "At last, one morning, we awoke to find our water pipes all frozen, and ourselves chilled to the bone." A neighbor stopped by and said it had been the coldest night that anyone could ever remember; the

mercury dipped to eighteen degrees Fahrenheit in Orlando and twenty-four degrees in West Palm Beach. This freeze caused the hanging citrus fruit to drop, but did not kill the trees. "That morning we finished breakfast with a dessert of orange-ice fresh from the trees. Cut open, and eaten out with a spoon, the frozen oranges made a dish fit for the gods."

January proved to be a relatively warm and wet month, and the orange trees sprouted new shoots as the branches filled with moisture and sap. Then, on February 9, 1895, the second freeze hit, just as cold as the first, but this one proved deadly for the trees. Most of the Central Florida orange groves were killed—frozen solid to the point that trees actually split and turned black from the excessive moisture and the new growth on the trees. "All of our neighbors had orange groves from which came their livelihood. In one night they changed from a condition of comparative wealth to the pinch of poverty," Birdie wrote. That year orange production in Florida plummeted from 6 million boxes to just 100,000. Many abandoned their groves and left the state; others realized that Florida needed to diversify its agriculture so that one event could not devastate its entire economy. The Deweys had enough of the cold. Fred remarked, "I tell you what let's do, Birdie: we'd better give up this cottage and fly back to our nest in the tropics." A neighbor adopted the kitten Peter the Tramp, and the Deweys headed back to the Blessed Isle.

The freeze's damage had reached West Palm Beach, where the coconut palms and other tropical foliage and fruits had suffered greatly. Down south in Miami, however, the damage had not been great. Julia Tuttle, a Miami pioneer and landholder, had urged Henry Flagler to extend his railroad to Miami so that prosperity and opportunity could extend southward. To convince him of the "frost-proof" nature of south Dade County, Tuttle sent him fresh orange blossoms that remained untouched by the freeze. Flagler did decide to extend his railroad southward, and Miami was the next area to be touched by the Flagler magic.

The Deweys were about to work some magic of their own, in a bit of a twisted tale on how they got caught up in the founding of one of Palm Beach County's largest cities. As mentioned previously, in 1892 Birdie purchased 160 acres of land at the foot of Lake Worth, in an area that was simply referred to as the "Hypoluxo Garden Lands." Lake Worth's west side had extremely fertile muck land, and at that time, it was considered to be the best farmland in the county, as the Everglades were still very much under water. The muck lands were well suited for tomatoes, and the coming of the railroad meant that farmers could load their crates for fast shipment to northern markets.

New settlers and speculators were also making their way south. Among them were two prominent Michigan men, William Seelye Linton and Nathan Smith Boynton. How the two men became acquainted is unknown. Linton had served in several political offices including the House of Representatives, and he even ran for president of the United States in 1896. Boynton was a Civil War major, had owned a Michigan newspaper and had served in many public offices in Port Huron, Michigan. He founded the Knights of the Maccabees in 1878, a fraternal organization that at its peak had more than 200,000 members. Both men ended up in South Florida in 1895, seeking a warmer climate and land.

Linton bought land along the oceanfront from Stephen Andrews on the barrier island where the town of Ocean Ridge is today. Andrews was the House of Refuge keeper at what became Delray Beach; in 1881, he had bought the eighty oceanfront acres from the State of Florida for ninety cents per acre. Linton sold the oceanfront land to Boynton, who started building one of the first homes to be located directly on the ocean, on a twenty-foot-high bluff where the Gulf Stream comes very close to shore. The common belief of how the associated town of Boynton was founded was that Major Boynton owned all the land in the area and had founded the town as well as the hotel.

Directly west of the oceanfront land along the west side of the barrier island, a swamp between the peninsula and barrier island was being dredged and widened to form the Florida East Coast Canal (today's Intracoastal Waterway), which created a canal for commerce and development. The land on the west side of the canal was still owned by Birdie. Linton offered her a deal for the land she could not refuse. She sold 120 of her 160 acres under a contract where Linton would pay her $6,000 for the land, plus 8 percent interest, to be paid over a four-year period. This was a huge profit. The agreement allowed Linton to subdivide the land into lots or farm plots. The Deweys kept 40 acres located along the canal. Linton kept buying land in the vicinity with small down payments, and soon he had platted a town about seven miles south of the Dewey land that he named the town of Linton.

As Boynton was building his home on the beach, he expanded his original plan and decided to build a hotel, which became the Boynton Hotel. He was inspired by Henry Flagler opening a second hotel in Palm Beach, which was built east of the Hotel Royal Poinciana and eventually named The Breakers for its location within earshot of the breaking waves. Boynton's new hotel provided jobs for local settlers and put the area on the map, as the hotel gained a fine reputation for its ocean bathing and excellent meals prepared with locally grown produce.

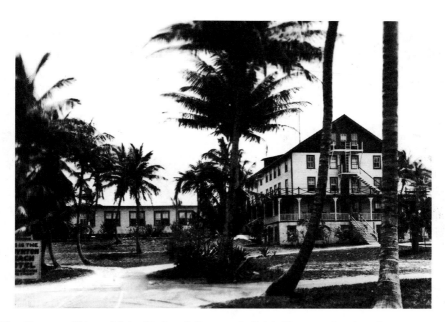

THE BOYNTON HOTEL. Major Nathan S. Boynton built his fifty-room hotel on the ocean beach. The hotel, well known for its fine dining utilizing produce raised on nearby farms, was opened in 1897. *Private collection.*

Linton sold lots and farm plots from the former Dewey land to new settlers, many from Michigan and Illinois, who had helped build Boynton's hotel and decided to stay and farm. The area was informally called "Boynton" as the hotel was the best-known landmark. The settlers planted tomatoes and other crops along the canal and planted pineapple in the sandy soils farther inland. According to Horace B. Murray, an early settler who supervised construction of Major Boynton's hotel, Franklin Sheen and George O. Butler surveyed the town. Neither Boynton nor Linton ever filed a plat for the town of Boynton, probably because they had no deed for the land, merely a contract for purchase.

But Linton's plans and schemes soon began to unravel. Most of his "purchases" were done with little or no cash; in the case of buying the Dewey land, he had only paid $100 up front as stated in the contract. To the south, too, in the town named after him, things were going bad as Linton was unable to pay for the lands he had bought. This left the settlers who had moved to the two towns in a real dilemma—they had been sold land by Linton to which he did not have title and he had given them worthless deeds. Settlers had already built homes and planted crops on the lands. Linton's townspeople were so disillusioned that they changed the name of the town from Linton to the town of Delray in 1898, and the city is known today as Delray Beach.

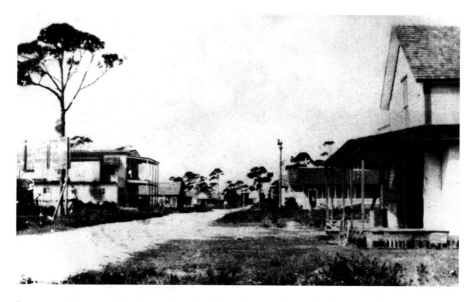

BOYNTON, FLORIDA. The Deweys' second Ben Trovato home, in Boynton, Florida, was their planned retirement home. The Deweys did much for the town's welfare, including donating lots to pay for street paving and starting a free library in the post office. *Courtesy Florida Archives.*

BOYNTON PLAT DETAIL. A excerpt from the plat for the town of Boynton, filed by Fred and Birdie Dewey on September 29, 1898. *Courtesy Palm Beach County Planning and Zoning.*

# The Deweys and the South Florida Frontier

These circumstances also left the area known as the town of Boynton in turmoil. Here, too, Linton had sold lots and farming tracts to settlers. Linton sold forty acres of the land to Boynton on March 5, 1897, which constituted the town area, but the sale did not mean much as Linton had no deed on the land. Boynton formed the Southern Florida Land Company and sold town lots for fifty dollars. Boynton began to realize that his late effort to save the town was not going to work. Boynton wrote to James E. Ingraham, Flagler's vice-president for the Florida East Coast Railway land department, in a March 31, 1897 letter: "I had a conference with Roberts, Dimick and Dewey and was unable to get any concessions worth considering hence I think I will have to abandon all further efforts to get matters in shape then."

After Linton stopped his payments, the Deweys filed a foreclosure lawsuit on September 15, 1897, against Linton and Boynton for nonpayment. The Deweys settled the case on October 29, 1897, with them regaining all their land from Linton and Boynton. From the settlement document: "N.S. Boynton will release and assign on his own behalf all the right, title and interest that he has obtained in said so-called Dewey contract by virtue of said assignment of W.S. Linton." For their part of the agreement, the Deweys released Boynton from any liability under the Dewey contract and noted that they would file the town plat.

The *Indian River Advocate* reported on December 10, 1897, that "defendants [were] surrendering their entire interests, and Mr. Dewey [was] regaining possession of his land, on which is located the town of Boynton. He will now proceed to deal directly with the settlers." Through these turn of events, Fred also gained a new position, serving as land agent for several interests, including the Florida East Coast Railway. "For two long years of uncertainty, the settlers in these two towns have held on to their bits of lands, waiting for the time to come when the titles would be in shape so that deeds could be made to them," the *Indian River Advocate* reported.

Linton, who was never a resident of the state of Florida, had orphaned the little town of Boynton; Fred and Birdie now adopted it and helped the fledging community grow and prosper. On September 26, 1898, the Deweys filed plats for the town of Boynton and for Dewey's Subdivision. The Deweys had every right to call their town anything they wanted, including "Deweyville." But they were friends with Major Boynton, a fellow veteran of the Civil War, and decided to name the town in his honor, a city that is known today as Boynton Beach, with more than sixty-eight thousand residents, making it the third-largest city in Palm Beach County.

In their past land dealings, the Deweys had essentially been speculators and not developers; now the role of shaping a town was thrust upon them. They

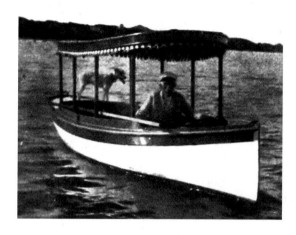

FRED DEWEY IN HIS BOAT. Fred Dewey at the helm of his naphtha launch, which Birdie nicknamed the "Calamity Jane" for the boat's tendency to break down. *Private collection.*

embraced this opportunity, with Fred acting as land agent and selling property that Henry Flagler had been granted for building the railroad on through to Miami. The Deweys built a home in Boynton, which they also called Ben Trovato, where Fred stayed while on business in the area or where the Deweys spent weekends. They began selling town lots and farming tracts to the settlers, who were finally able to be issued genuine deeds to their land. These were all the land entry sales records that were found in the tract sales books at the Palm Beach County Courthouse when research for this book was started.

Fred bought a naphtha launch motorboat to quicken travel to the Boynton area and all points along Lake Worth. When first purchased, its motor proved quite untrustworthy and left Fred and his passengers stranded in very remote locations. Because of this, Birdie christened the boat the "Calamity Jane."

At the West Palm Beach Ben Trovato, Birdie entertained visiting family members and kept busy writing articles for publication at the national and local level. Palm Beach's resident women decided to publish their own literary magazine as a fundraiser for the Royal Poinciana Chapel in Palm Beach. Birdie's friend Ruby Andrews Myers served as editor, and the women produced the 1896 *Lake Worth Historian*. Birdie contributed an alluring short story called "A Lake Worth Romance," a sweet tale of love lost and found again. An excerpt: "This 'light that never was' may be freely translated as romance. Practical people often deride it, but by so doing, they only show ignorance of its charm. It is a priceless gift. One who possesses it goes through life keeping step to music unheard by others."

Her sister-in-law Lillian Spilman, married to brother Lewis Hopkins Spilman, wrote an essay about a summer vacation in Palm Beach, something

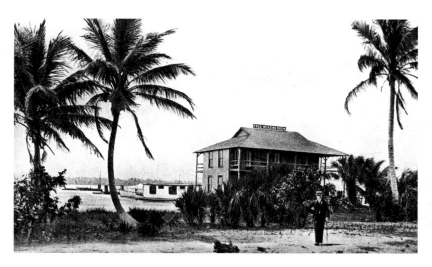

WEST PALM BEACH FREE READING ROOM. Books were an important part of West Palm Beach's early history. The Free Reading Room, located in a city park on the waterfront, was opened in 1895. Birdie's books still reside in the Florida Room at the Mandel Public Library of West Palm Beach. *Courtesy Florida Archives.*

that most people did not think would be enjoyable, given the heat and mosquitoes. She wrote, "No snobs to worry the genial denizens and natives in summer—only a few mosquitoes—and the naturally hospitable Floridian is a warm, hearty living exponent of best virtue."

Back in Illinois, Birdie's father, Reverend Jonathan Edwards Spilman, passed away on May 23, 1896, at the age of eighty-four. It is not known for sure if he visited Florida and the Blessed Isle, but Birdie did write of the "Old Dominie" visiting, which is usually how she referred to her father in her writings. Other family members visited, including Birdie's older sister, Anna Louise Spilman. The March 3, 1898 *Tropical Sun* reported that Anna Louise was taking over a farm in the town of Boynton: "Miss Spilman will be Boynton's first lady gardener, and we all wish her the best of success in her undertaking." The cottage on the property was renamed Spilman Cottage, and many fine parties were held there. From the September 11, 1898 *Tropical Sun*: "A most delightful time was experienced by those present, due to the courtesy of F.S. Dewey, a number of terpsichorean [dancing] devotees gathered at Spilman Cottage, where several hours were devoted to the light fantastic."

Among all these hurried events of developing a town and entertaining family, Birdie was writing her breakthrough book, one that brought her more literary fame than anything else she wrote. This coincided with the new century, and the march of time would soon bring changes that again challenged her heart.

# A New Century and New Challenges

T he year 1899 was certainly a remarkable one in America, especially in the Dewey household. The new century was at its dawn, and Birdie wrote the following in a New Year's essay, published in the *Maysville Public Ledger*: "As the old year dies the new year is born. The hour of passing from old to new is one of vigil—of remembrance—of hope. From a dawn sky, gilded by the sun's first ray, comes the glad new year—a boat sailing wing-and-wing loaded down to the water's edge with gifts. It speeds us-wards dashing up the spray with its golden prow, leaving in its wake a ruffled tract of sparkling light."

For Birdie, she had fulfilled perhaps her greatest personal dream: the publication of her first book. It is not known to how many publishers she had submitted *Bruno*, but it was published in the fall of 1899 by Little, Brown and Company in Boston, which was founded in 1837 and was one of America's largest publishing houses. Birdie was in good company with other Little, Brown and Company authors, including Louisa May Alcott, Emily Dickinson and Edward Everett Hale.

National acclaim for *Bruno* was immediate, and several publications featured glowing reviews. The *Boston Herald* noted, "One is not obliged to be a lover of animals to appreciate Bruno's friendship and the honesty of purpose and delightful comradeship which this little book disposes." The *Art Exchange* reported, "In *Bruno* there is shown the mind of an artist with keen sympathy for and understanding of animal nature." Joseph Leopold Borgerhoff, critic and author, wrote of *Bruno* in the *Library of Southern Literature*: "In *Bruno* Mrs. Dewey gives a delightful picture of her first dog. It is skillfully interwoven

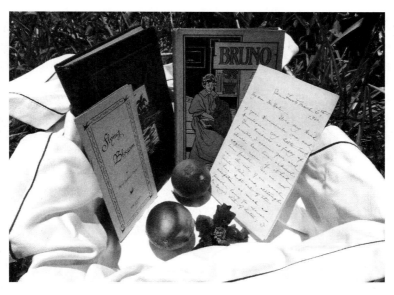

BYRD SPILMAN DEWEY'S BOOKS AND LETTERS. In addition to her 1899 bestseller *Bruno*, Byrd Spilman Dewey published many of her short stories in pamphlet form, including "Flying Blossom," "Peter the Tramp" and "Who Seeks, Finds." *Private collection.*

with record of her early struggles, joys, adventures in her adopted state. Mrs. Dewey's English is plain and direct; she knows the secret of saying things in a quaint and picturesque way; hers is a style with a merry twinkle."

The *Florida Times-Union* noted, "The world is not crowded with books by authors who make their home in Florida. The book is one which will touch deeply readers of all classes, whether lovers of animals or not, and one that will interest young and old." Finally, the *New York Times* wrote, "It is a story of a dog's life and deeds, and of the faithfulness which made him a genuine companion to his mistress. Not a learned dog like Diomed, not an elegant morsel of refinement like Loveliness, Bruno is a dog whose owners do not think that heaven will be quite complete for them until they can go over to the 'Happy Hunting Grounds' and get Bruno to live with them again."

The book sold well, and by 1900, it was already in its second printing, with more than 100,000 copies in print. The *Lake Worth News* reported on November 1, 1900, "Mrs. Fred S. Dewey has received a letter from Messrs. Little, Brown and Co. of Boston, saying that the orders for her book *Bruno* continue to increase and that it is now being introduced for supplementary reading in some of the Eastern schools." *Bruno* was important in another way in that it was certainly one of the first novels ever to be written in West Palm Beach, and it was also set in Florida, making it a milestone event in

Palm Beach County's literary history. The year 1901 also marked Birdie's entry into Marquis's *Who's Who*, which was founded in 1899 and contains concise biographies of influential Americans; inclusion in the book was by invitation only, and Birdie was listed until her passing in 1942.

In a March 6, 1900 letter to Nathan Haskell Dole, a prominent writer and critic, Birdie wrote, "My little book has brought many delightful letters. I have the largest drawer in the new desk Santa Claus brought me nearly full of them. My husband is so proud of me and it makes me very happy." Certainly the fame from *Bruno* opened the doors to more opportunities. In 1901, *Vogue* magazine commissioned Birdie to write a series of articles about the cats at the Blessed Isle. The four *Vogue* stories were the beginning of her second book, *The Blessed Isle and Its Happy Families*, published in 1907, which chronicled life at Ben Trovato with Fred, Birdie and their many pets. The cats and their misadventures were the main characters. J.L. Borgerhoff commented, "These stories of Catsie, Roi, Deedie, the Robber Cat, the Twins, Peterkin and others are told with much detail both interesting and amusing, and a great deal of cat lore and cat psychology is to be found in them."

As West Palm Beach was ever encroaching on the Blessed Isle, and Palm Beach was booming with new hotels and luxury homes, Fred was interviewed in the *Tropical Sun* on October 6, 1906, as to what he envisioned for the growth of the area: "Mr. Dewey also spoke encouragingly of the proposed drainage scheme which is to be carried out by the various land companies interested so extensively west of this city, and he believes that the lands will, when drained and reclaimed, prove all that has been claimed for them, producing a variety of crops that will find ready market and demand good prices." At that time, any land typically more than one mile inland was considered to be the Everglades. Now, much of the land has been drained, as Fred predicted. It served first as agricultural lands until being developed for luxury housing and equestrian communities known as the village of Wellington and Royal Palm Beach.

The Deweys were gaining new friends and entry into elite circles. Among their friends were Henry Phipps and his wife, Anne Childs Shaffer Phipps. Henry Phipps was an entrepreneur and partner to Andrew Carnegie, whose Carnegie Steel Company had made them both very rich men. Phipps subsequently became one of America's greatest philanthropists. Birdie revealed this friendship in a letter to Hugh Fullerton, who had enquired as to whom she thought was the most interesting woman in the world. She replied, "The most interesting thing in the world is LIFE itself, and therefore I'd say the most interesting woman IN THE WORLD is a successful mother. By successful I mean a mother who has given the world strong, useful, happy

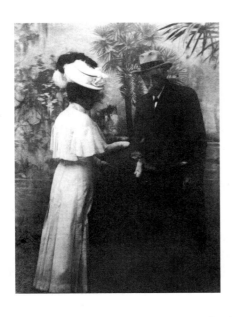

FRED AND BIRDIE DEWEY IN JACKSONVILLE. Pasted inside the cover of a copy of the book *Bruno*, this 1907 image shows Fred and Birdie Dewey at a Jacksonville photography studio. *Private collection.*

pure-blooded men and women. Such a woman is the most charming and alluring of companions, the most dependable of friends, and most worthy of the highest honor." Mrs. Phipps, in Birdie's opinion, was such a woman. Birdie also had an active correspondence with Ellen Axson Wilson, first wife of President Woodrow Wilson. Mrs. Wilson wrote a letter in 1905 to Birdie when Woodrow Wilson was president of Princeton University: "I am sending the photographs including one of myself since you wished it."

Ben Trovato was truly a place of culture, music, literature and good company. In an undated article from the *Florida Times-Union*, the home was described as follows: "Their home, Ben Trovato, is the center of a most delightful circle, and many of the prominent hotel guests and cottagers find their happiest moments there surrounded by the art treasures Mr. and Mrs. Dewey have collected." That charm and friendliness was not just lost on their adult friends. Many children were welcomed at Ben Trovato, as well as at all homes in which the Deweys resided. In Judge Hoover's research on Birdie, he interviewed several people who knew her when they were children in the fledging West Palm Beach. Mrs. Sara Dean recalled, "Mrs. Dewey was small, fluttery and vivacious with dark hair and dark eyes, was very much interested in cats and used to entertain me in her front room." Living nearby in an area called Crane's Nest was Frieda Crane Prior, who gave this wonderful insight: "I was in and out of Mrs. Dewey's home almost every day. She loved children although she did not have any of her own. She was crazy about cats, and her doors had little doors in them so they could go in and

out. She had difficulty with alligators trying to catch her cats. She was small with black wavy hair. "

This description of the "doors with little doors" matches what Birdie describes in her book *The Blessed Isle and Its Happy Families*, where Fred had cut out squares at the bottom of the doors and Birdie had made little sailcloth covers. All the cats except one quickly mastered the idea that they could freely scamper from inside the house to outside. She wrote of the one cat that just didn't get it: "Peterkin found it to be an unsolvable puzzle. She was almost always to be found sitting on one side or the other of it, waiting for someone to come and open the door."

Cats were numerous at the Blessed Isle, and finally a new dog found its way to their hearts, so long after the passing of Bruno. In Palm Beach, a litter of puppies, half bulldog and half pointer, had arrived. Fred picked out a little puppy for Birdie; because of his clumsiness, the little pup was christened "Foozle." Foozle was soon joined by a second dog, Van, a beautiful collie from the Biltmore estate in North Carolina. The two were referred to by Birdie as "Comedy and Tragedy" for their antics at the Blessed Isle.

Birdie hints in several places that Fred's health was in decline. They began spending more time in Jacksonville, where hospitals were available. At that time, West Palm Beach had few physicians and no real hospital until 1914, when the six-bed "Emergency Hospital" opened. She knew that their days at the Blessed Isle might be coming to an end; handling such a large house and property would be too much for her: "Then we realized that our Blessed Isle must be left for a longer period; and perhaps for always."

She speaks of an "accident" that occurred with Fred but does not provide any detail on what it might have been—perhaps a serious fall. He convalesced at Ben Trovato until well enough to travel to Jacksonville. In 1906, they leased Ben Trovato and relocated in Jacksonville. They returned for the season in 1908. The *New York Herald* reported on January 12, 1908, "They have leased their place and will occupy the Brelsford villa The Banyans. Ben Trovato was formerly the rendezvous for men and woman of the literary and social world."

Certainly leaving the Blessed Isle and Ben Trovato, their home since 1890, was difficult. They had watched Palm Beach and West Palm Beach grow from a small collection of cottages, palmetto shacks and tents to a world-class resort. She wrote of leaving her rose garden at the Blessed Isle, "The roses, my especial friends, seemed to feel a premonition of separation. They reached out clinging arms to wrap their branches around me and to hook thorn-fingers so securely in my garments…this garden ever haunts my dreams, and I hope to find, somewhere in Paradise, a corner just like it."

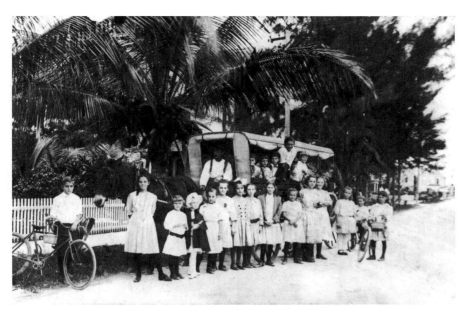

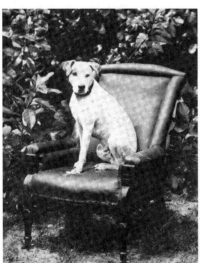

*Above*: SCHOOLCHILDREN IN WEST PALM BEACH. Children were always welcome at Ben Trovato, where Birdie Dewey would entertain them with her stories of her cats and dogs. *Courtesy Florida Archives.*

*Left*: FOOZLE IN HIS CHAIR. This image, from Birdie Dewey's book *The Blessed Isle and Its Happy Families*, portrays Foozle, a half-bulldog/half-pointer pup, the first dog to join the Dewey household after Bruno. *Private collection.*

The Deweys sold the Blessed Isle and Ben Trovato in 1909 and moved to their home in Boynton. Fred also retired from his land agent position with the Florida East Coast Railway. Bertha Daugharty Chadwell remembered the second Ben Trovato in a 1966 interview with Judge Earl Hoover: "They called their Boynton home 'Ben Trovato' and over their front door stood a big sign Ben Trovato. It was a big two story house facing east. The house was destroyed by fire about 1920. I drove them to Palm Beach to see Mr.

BRELSFORD HOUSE, THE BANYANS. Edmund M. Brelsford began construction on the mansion known as the Banyans in 1888, and the house was completed in 1903. The Brelsford family operated the first general store in Palm Beach. The Deweys rented the Brelsford home during the 1908 Palm Beach season. *Courtesy Library of Congress.*

BEN TROVATO, 1906. This last known photograph of Ben Trovato taken when the Deweys owned the house shows the addition of shutters. *Courtesy Historical Society of Palm Beach County.*

Flagler; Flagler was always anxious to talk business with Mr. Dewey. Dewey and Flagler would always go into Mr. Flagler's office and talk; Mr. Dewey was jolly and somewhat older than his wife."

There was one unfulfilled dream that the Deweys had from their earliest Florida pioneer days that was now realized in Boynton: a successful orange grove. Fred had been told that oranges could not be grown in the muck land along the coastal canal. He persisted, and his grove was the first successful orange grove on the west side along the canal in Boynton. Its success was chronicled in several publications, including the *Florida East Coast Homeseeker* and the *Florida Agriculturalist*. From the former: "In January 1902, Mr. Fred S. Dewey planted a seven-acre grove of citrus trees on the muck lands at Boynton as an experiment which has resulted in great success." Fred's grove had many citrus varieties, as reported in the *Maysville Public Ledger*: "Mr. F.S. Dewey of Boynton finished shipping oranges Tuesday with a shipment of 256 boxes. This makes a total including mail orders and individual shipments of 800 boxes of tangerines, grapefruit and oranges."

The Deweys did much to support the town of Boynton. To help pave streets, the Deweys donated the proceeds from the sale of downtown lots. The Deweys also initiated an important step in any town's development: starting a library. Boynton's history had previously recorded that the library was started in 1911 by the Boynton Woman's Club. But a June 10, 1910 article that appeared in the *Miami Metropolis* shed new light on how what probably was the first library in Boynton began: "Before leaving they [the Deweys] made a gift to the citizens of Boynton and the surrounding territory of a 'Free Reading Library,' which is located in the Post Office building in charge of Mrs. Chas. W. Pierce. It was their desire to help those who remained at home to enjoy the summer—by always having good company—good books. We have no one who shows more public interest in the welfare of the town than Mr. and Mrs. Dewey." The Boynton Woman's Club also started a library in 1911, and at some point the collections were probably merged. That is the most logical conclusion in that today's city library clearly traces its roots to the Woman's Club Library.

But the happy times in Boynton were short-lived. They had intended to retire in the town they had so carefully nurtured, but circumstances did not allow this happy ending to occur. They sold the house in Boynton and ventured northward once again, as Fred's declining health steered their next moves.

# The Bird Whisperer and the Journey Home

Fred and Birdie spent the summer of 1910 in Maysville, where Birdie had spent her childhood years. She wrote in the *Maysville Public Ledger*, "To come back, after an absence of more than thirty years, to a home town, hallowed by memories of early childhood and youth, is an experience to move the soul. All is more beautiful—more 'happifying' than fondest memories dream." In August, the local newspaper reported that they were leaving for Johnson City, Tennessee, where Fred was admitted to the Mountain Home Branch Hospital, a home for Civil War veterans. He was seventy-three years old, and his hospital admission record listed the following conditions: "Some defective vision both eyes, cardiac hypertrophy, injury to head, paralysis agitans [Parkinson's disease]." The head injury notation probably explains the "accident" mentioned in *The Blessed Isle* book. At that time, there was little or no treatment for such ailments as Parkinson's disease, and it was probably becoming increasingly difficult for Birdie to care for him.

At the military home, the government provided the men with surplus Civil War uniforms and simple meals and entertainment such as a library and card room. Fred received a pension of fifteen dollars per month. It is unclear at this point if Birdie took an apartment nearby or returned to Florida to live alone. In April 1915, Fred was transferred to another military hospital, the Southern Branch Hospital in Virginia. On this admission record, the diagnoses were more ominous: "Defective vision, old injury to the head, cardiac hypertrophy, and atherosclerosis, senility." The senility diagnosis at

age seventy-nine may be another reason why Birdie was not able to care for Fred. She is listed as wife, and her home is listed as West Palm Beach.

Birdie republished a few of her short stories in pamphlet form, but she did not write another major work. She was sixty years old in 1916 and again yearned for the beauty and culture of the Lake Worth Country. She purchased a cottage on Seabreeze Avenue in the town of Palm Beach, just a few blocks from the Hotel Royal Poinciana. She was listed in the Palm Beach directory as "Authoress, Ben Trovato." The Palm Beach cottage became the third and final house to bear the name of Ben Trovato. Most mail addressed to her was simply noted, "Mrs. Byrd Spilman Dewey, Ben Trovato, West Palm Beach," and it always found her.

Judge Earl Hoover contacted a subsequent cottage owner who reported that when he took possession of the cottage, a large sign over the door read "Ben Trovato." The subsequent owner lived in the cottage for about ten years, but termites caused him to demolish it and build a new house, which stands to this day. He mentioned that the house was filled with built-in bookcases, a telltale sign of it being a Dewey residence. Birdie lived alone there in Palm Beach, visiting friends such as Amy Phipps Guest, daughter of Henry Phipps. She had her pets once again: a cat named Billie and a German Shepherd named Fritz. They certainly provided the comfort and protection she needed, living alone for the first time in her life. Fred lingered on at the military hospital in Virginia; he was discharged in December 1917, probably to spend one final Christmas with his beloved Birdie. On January 24, 1918, he reentered a military hospital, this time the Pacific Branch Hospital at Sawtelle, California, perhaps for

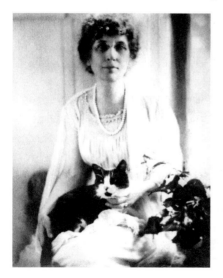

the warmer climate. Whether Birdie stayed with him there is unknown, but California was quite a journey from Florida in those days.

Finally, on January 5, 1919, death claimed Frederick Sidney Dewey at the

BYRD SPILMAN DEWEY AND CAT BILLIE. Found inside a copy of *Bruno*, this image of Birdie at age sixty was taken at the final Ben Trovato cottage in Palm Beach. Typical of Birdie, the cat Billie sits contentedly in her lap. *Private collection.*

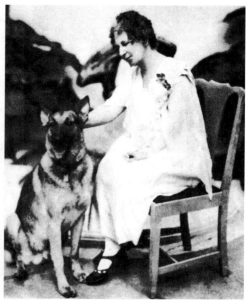

*Left*: GRAVE OF FRED S. DEWEY. Fred Dewey passed away on January 5, 1919, and was buried at the Los Angeles National Cemetery. *Courtesy Kim S. Jenkins.*

*Right*: BYRD SPILMAN DEWEY AND DOG FRITZ. Taken at the home of Mrs. Frederick Guest, Birdie is shown in her early sixties. Amy Guest was the daughter of Birdie's dear friend, Mrs. Henry Phipps. *Courtesy Janis Lydie Hebert.*

age of eighty-two. His obituary from the *Palm Beach Post* read: "Frederick S. Dewey, for a number of years a resident of this county, both in this city and Boynton, died at the Old Soldier's Home in Sawtelle, Santa Monica, California. His wife, Byrd Spilman Dewey, was with him at the time of his death." Coincidently, that same week, another important Palm Beach pioneer passed away: Elisha "Cap" Dimick, who ran the Cocoanut Grove House, Palm Beach's first hotel and served as the first mayor of Palm Beach. Few persons had seen more development and change in Palm Beach than these two brave pioneers of the Lake Worth Country.

Now, at the age of sixty-three, Birdie was a widow. She followed her own advice, as stated in *From Pine Woods to Palm Groves*: "When all else fails, Wisdom commands: Seek changed environment. Go somewhere and begin anew." She sold the cottage in Palm Beach and moved to Winter Park, near Orlando. Property sales records for this time period once again show Birdie buying and selling real estate, this time lots that were platted in the subdivisions that were popping up all over Florida as the second Florida land boom was starting.

# The Deweys and the South Florida Frontier

With this new life as a widowed woman, an emergent cause became her final life's work. In 1920, Birdie became the field secretary of the Florida Audubon Society, which was headquartered at Rollins College in Winter Park. She traveled the state, lecturing on conservation and appearing before city commissions to ensure that bird sanctuary ordinances were passed. From the April 21, 1921 *Kissimmee Valley Gazette*: "Mrs. Byrd Spilman Dewey, of Winter Park, was in Kissimmee yesterday, making arrangements to come to this city at an early date and impress upon the citizens the need of creating a bird sanctuary. Mrs. Dewey has been speaking in various portions of the state on this topic—and at Haines City she was magnificently received at a very successful gathering."

Her ability to tame wild birds was legendary and was noted by many in Judge Hoover's research. Lena Clarke, who knew Birdie at Ben Trovato in West Palm Beach, wrote: "She could mock any bird that lived. She could just talk to them and they came to her. People used to say that she was a little bird and that she had a bird's throat. She was beautiful. Children followed her about in order to hear her BYRD calls (as we called them) and try to imitate the feathered friends." Ted Utsey of Jacksonville recalled, "She was a bird caller and had a bird sanctuary in front of her house. She could whistle and those birds would just come running and she would feed them." Birdie commented on this as well in a 1927 article that she wrote in the *Florida Naturalist*: "I whistle them in, and they come trustingly to me showing that they have no fear of me, because I speak their own language." She noted how she could work in her garden, surrounded by birds, but if a strange voice was heard, they were gone in an instant.

In the 1920s, conservation and sustainability were not topics of interest as they are today. She could see what was happening to the environment and feared what the future held for Florida: "If we who now hold the world's law making in our hands, do not give attention to conserving our natural resources, then the children, coming after us, will inherit a looted estate."

She lived in several different homes in the Orlando area and found herself once again in Jacksonville. Very little information was found on her activities from about 1929 to 1935. These were, of course, the years of the Great Depression, and depending on how her money was secured, she could have lost money in bank failures. Certainly Florida property values plummeted; her holdings in Palm Beach County had been closed out by 1925.

She did have family in Jacksonville. Her brother William Magill Spilman lived there for many years and passed away in 1926. Birdie purchased a small bungalow on Home Street in South Jacksonville, where she lived,

tending to her birds. It is not known why she ceased writing; perhaps, with Fred's passing, she no longer had the inspiration she needed to write. She was not alone in Jacksonville. Her wide circle of friends was always with her, as noted in a 1931 letter, "[a]s I have no children of my own. All of mine are adopted. I wished a house-full of babies, but my late husband wanted me all to himself, so since I am a widow, a lot of young people have adopted me, the older ones as 'Little Mother' and now their children call me 'Gammy' which is very 'happy-fying' to me."

She helped children in the neighborhood with their studies. Ted Utsey recalled, "She was a very kind person and never too busy to come out and talk to you. She'd tell us beautiful stories. She wore glasses and long dresses and was not very tall—not over five feet. We talked about her once living in Palm Beach. She told me of the train ride to get near there, and what fun she had."

And it was fun. During her sixty years in Florida, Birdie saw Florida grow and develop from an untamed place to one of refinement and civilization. In her last publication, she offered the best clue that all she wrote had happened, from the *Florida Naturalist*: "My greatest hold on the interest of those to whom I speak is that my stories of birds, trees, and beasts, great and small, are not what the children call 'made up.' They are true, and are from my own experiences and observation."

On April 1, 1942, Birdie drew her last breath, and her journey home was complete. From the *Florida Times-Union*: "Friends from all stations in life are mourning the death of Mrs. Byrd Spilman Dewey, 86, who for many years resided in a tiny bungalow on Home Street and devoted her time to Florida bird protection and forest conservation." On the subject of dying, she had written to Rosamond Gilder, "I have always prayed to go suddenly—no dying by inches—and my affairs will be settled by strangers (to my own people) here." She died in the home of a friend. According to her will, she wished to be cremated and that a handful of her ashes be taken to The Breakers Hotel pier in Palm Beach and spread to the sea. Her only surviving immediate family member was her older sister, Anna Louise Spilman, who instead of cremation had her interred at the Greenlawn Cemetery (former Dixie Pythian Cemetery) in Jacksonville, in an unmarked grave, where her brother William and baby, Elizabeth, had been buried.

Seventy years after her death, her final wishes were fulfilled in a symbolic way. The authors burned one of her short stories, and the resulting ashes were spread to sea at The Breakers Hotel beach on her birthday in 2012. The Breakers Hotel pier was no longer extant, as the 1928 hurricane severely damaged the pier and the hotel demolished the pier. The authors felt that

THE BREAKERS HOTEL BEACH. Flagler built and operated an additional hotel, opening in 1896 as the Palm Beach Inn. Flagler renamed the hotel in 1901 as the Breakers Hotel, as guests requested rooms "over by the breakers." The hotel is still in operation today. *Courtesy Library of Congress.*

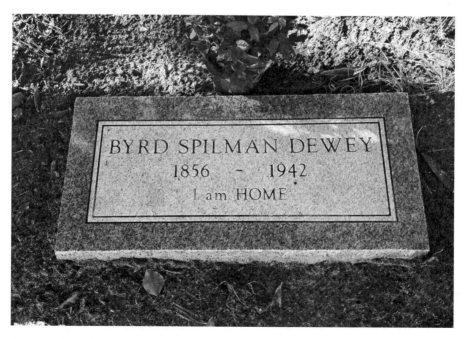

GRAVE OF BYRD SPILMAN DEWEY. Byrd Spilman Dewey passed away on April 1, 1942, and was interred at the Greenlawn Cemetery in Jacksonville in an unmarked grave. In 2012, the authors of this book purchased a marker for her grave. *Private collection.*

Birdie's unmarked grave in Jacksonville was not the way that someone who had contributed so much to Florida literature, to Palm Beach County and to the birds and wildlife of the state should be remembered. The authors purchased a marker for her grave at the Greenlawn Cemetery, with the inscription, "I am HOME," to signify her vision of heaven. Birdie always expressed the word "HOME" in capital letters, so her tombstone was engraved in this way.

The Deweys' lands in Florida were developed in the subsequent decades. If still held today, the properties would be worth tens of millions of dollars. The twenty acres in Zellwood is still fairly rural, dotted with a few houses and businesses. The town lots in Eustis form part of the parking lot for the Eustis Memorial Library. The seventy-six-acre Hermitage site along Lake Mangonia was initially used as a pineapple plantation, but a 1909 blight wiped out pineapple production in South Florida and it was sold to developers. It is now in mixed use, with housing and industry. The city of West Palm Beach purchased part of the land in 1913, and it became the pauper's cemetery. The cemetery was used as the mass burial site for the African American victims of the 1928 hurricane; in 2002, it was added to the National Register of Historic Places.

The Blessed Isle property was initially subdivided into two housing developments called the Croton Park and Nichols-Baldwin subdivisions; a large lot still surrounded the Ben Trovato house. A subsequent owner added a north wing to the house. The owners abandoned the house in the 1960s, and vagrants stripped and vandalized the residence. The property owners demolished Ben Trovato in 1970 to make way for the nineteen-story North Rapallo Condominium. A parking lot now stands on the footprint of Ben Trovato.

Fred's 80 acres west of the downtown West Palm Beach area was planted with pineapples by the Clarke family and then developed in the 1920s housing boom as the Parker Ridge neighborhood. Birdie's 160-acre plot at the southern foot of Lake Worth contains the original town of Boynton plot and is today known as the city of Boynton Beach. The Boynton Ben Trovato home burned down in 1920, and a gasoline station now occupies the property. The land along the Intracoastal Waterway where the tomatoes grew and Fred had his orange grove has restaurants, condominiums and several natural preserve areas. The Palm Beach Ben Trovato was demolished in the 1930s and replaced with a concrete block home.

The Broward County lands were in two sections, each 640 acres. The northern piece is mixed use, including housing and the Fort Lauderdale Executive Airport. The southern piece composes a large portion of the city of Hollywood with housing and businesses.

# The Deweys and the South Florida Frontier

BYRD SPILMAN DEWEY AND HER DOGS. Pictured with her two dogs, Foozle and Van, Byrd Spilman Dewey wears a bonnet as her preferred head covering. She shunned the fashion of the time and refused to wear feathered hats in protection of Florida's birds. *Private collection.*

Birdie's bungalow on Home Street in South Jacksonville has long since been demolished, and only one cottage remains on the street.

So the Deweys' legacies are many, as the lands they settled have evolved to the landscape we see today. But one legacy remains the same: Birdie's writings. Perhaps no other words can better express her beliefs, philosophy and outlook on life than her essay entitled "Realities," which was written when their dog Van had passed away following a long illness. From *The Blessed Isle and Its Happy Families*:

> *Pondering these things, we arrive at the truth, old as human feeling, that the only realities of life are the things that do not exist. What are called realities—life's necessities—these never quicken the pulses, nor choke the breath with hurried heart-beats.*
>
> *But the intangibles—love, art, beauty, music, and again love; for love, in all its many kinds and degrees, is what gives meaning to art, beauty and*

*music—these are the things that stir us to the depths—these are the things that grasp us with resistless power, dragging us up by the roots to throw us down quivering where we perish; or else take ahold new with our soul-fibers.*

*These non-existing realities make of earth a garden of delight; or a desert swept by simoons and scorched by droughts.*

*Nothing else really matters—or rather, everything else follows as the non-existing verities set the pace.*

The Deweys lived in the realities of life in early South Florida. They never gave up on their adopted state, even though the heartaches and failures were many. In a letter, Birdie stated the Taylor family motto: "What I attempt, I accomplish." And what they accomplished in their sixty years in Florida, through pioneering and prosperity, teaches much about perseverance and hope. Birdie's literary works live on, and the Deweys' souls dwell through eternity in their Blessed Isle paradise of HOME.

# *Bibliography*

Blackman, William Fremont. *History of Orange County, Florida; Narrative and Biographical.* Chuluota, FL: Mickler House, 1973. Originally published in 1927.

Brinton, Daniel. *A Guide-book of Florida and the South: For Tourists, Invalids and Emigrants.* Philadelphia, PA: George Maclean, 1869.

Coleman, J. Winston. *A Centennial History of Sayre School, 1854–1954.* Lexington, KY: Winburn Press, 1954.

Daugharty, Hazel H. *Major Nathan Smith Boynton and His Family.* Boynton Beach, FL: self-published, 1972.

Dewey, Adelbert. *Life of George Dewey.* Westfield, MA: Dewey Publishing Company, 1898.

Dewey, Byrd Spilman. *The Blessed Isle and Its Happy Families.* St. Augustine, FL: Press of the Record Company, 1907.

———. *Bruno.* Boston, MA: Little, Brown and Company, 1899.

———. "From Pine Woods to Palm Groves." *Florida Review* 1 (1909). Series of articles that eventually was turned into a book of the same name.

————. *Peter the Tramp*. West Palm Beach, FL: self-published, 1916.

————. "Some Bird Notes." *Florida Naturalist* 8 (1927): 23–25.

Gilpin, Mrs. John R. "To Miami, 1980 Style." *Tequesta* 1 (1941): 89–102.

Hoover, Earl R. "J.E. Spilman—Kentucky's Long-Lost Composer of a World-Famous Melody Rediscovered." *The Register of the Kentucky Historical Society* 66, no. 3 (1968): 222–41.

————. *Report on Mrs. Byrd Spilman Dewey*. Cleveland, OH: self-published, 1967.

Knight, Lucian Lamar. *Library of Southern Literature*. Atlanta, GA: Martin & Hoyt Company, 1907.

Lanier, Sidney. *Florida: Its Scenery, Climate and History*. Philadelphia, PA: J.B. Lippincott & Company, 1876.

Linehan, Mary Collar. *Early Lantana, Her Neighbors & More*. St. Petersburg, FL: Byron Kennedy and Company, 1980.

Linehan, Mary Collar, and Marjorie Watts Nelson. *Pioneer Days on the Shores of Lake Worth, 1873–1893*. St. Petersburg, FL: Southern Heritage Press, 1995.

Melville, Malcolm. *The Spilman Papers*. Forestville, CA: self-published, 1965.

Metcalf, John Calvin. *Library of Southern Literature*. Atlanta, GA: Martin & Hoyt Company, 1923.

Myers, Ruby Andrews. "Newspaper Pioneering on the Florida East Coast, 1891–1895." *Tequesta* 43 (1983): 51–62.

Pierce, Charles. *Pioneer Life in Southeast Florida*. Coral Gables, FL: University of Miami Press, 1990.

Robinson, Tim. *A Tropical Frontier: Pioneers and Settlers of Southeast Florida, 1800–1890, a Comprehensive History*. Stuart, FL: Port Sun Publishers, 2005.

Spelman, Henry. *Relation of Virginia*. London, England: Chiswick Press, 1872.

Stowe, Harriet Beecher. *Palmetto Leaves*. Gainesville, FL: University of Florida Press, 1968.

Tuckwood, Jan, and Eliot Kleinberg. *Pioneers in Paradise: West Palm Beach, the First 100 Years*. Atlanta, GA: Longstreet Press, 1994.

## NEWSPAPERS AND MAGAZINES

*Bradford County Telegraph.*
*Christian Union.*
*Florida East Coast Homeseeker.*
*Florida Star.*
*Florida Times-Union.*
*Gallopolis Journal.*
*Good Housekeeping.*
*Kentucky Statesmen.*
*Kissimmee Valley Gazette.*
*Ladies Home Journal.*
*Lake Worth News.*
*Miami Metropolis.*
*New York Herald.*
*New York Times.*
*Tropical Sun.*

# *Index*

Tocoi, Florida  40, 44, 49
town of Linton. *See* Delray Beach,
        Florida
Transylvania College  22
*Tropical Sun*  73, 74, 78, 79, 80, 81, 87,
        89, 90, 94, 101, 104
tuberculosis  31, 32, 34, 37
Tuttle, Julia  95

## U

Union Congregational Church  91

## V

*Vogue*  104

## W

Westpalmbeach. *See* West Palm Beach
West Palm Beach, Florida  16, 17, 56,
        59, 62, 69, 84, 89, 90, 91, 93,
        95, 103, 104, 106, 111, 113, 116
Wilson, Mrs. Woodrow  105
Wilson, President Woodrow  105
Winter Park, Florida  112, 113
Woodward, Laura  85
Worth, General William Jenkins  16, 54

## Z

Zellwood, Florida  43, 44, 45, 46, 47,
        48, 50, 116

# About the Authors

D r. Ginger L. Pedersen is a college administrator and history researcher. She received her master's degree in psychology and her doctoral degree in higher education administration from Florida Atlantic University. A native Floridian, Dr. Pedersen has always been intrigued by Florida's history and Palm Beach County in particular; her earliest Florida ancestor  arrived in 1886. She maintains two local history websites and serves on a historic resources preservation board. Dr. Pedersen has given speeches on various historical subjects to several local audiences. This is her first book.

 A resident of Palm Beach County since 1987, Janet M. DeVries is an archivist and historian. DeVries graduated from Palm Beach State College and is finishing her Bachelor of Arts degree in history at Florida Atlantic University. She is the author of four books, including *Around Boynton Beach* (2006) and *Sport Fishing in Palm Beach County* (2008). DeVries is a member of the American Association of Archivists, Society of Florida Archivists, Gold Coast Archivists, American Association for State and Local History, Genealogical Society of Palm Beach County, Florida Historical Society, Historical Society of Palm Beach County, Boynton Beach Historical Society and the Lantana Historical Society. Her roots in Florida go deep; her paternal grandfather, Fred Gardner, was a real estate agent and property appraiser in South Florida in the 1930s.

Visit us at
www.historypress.net